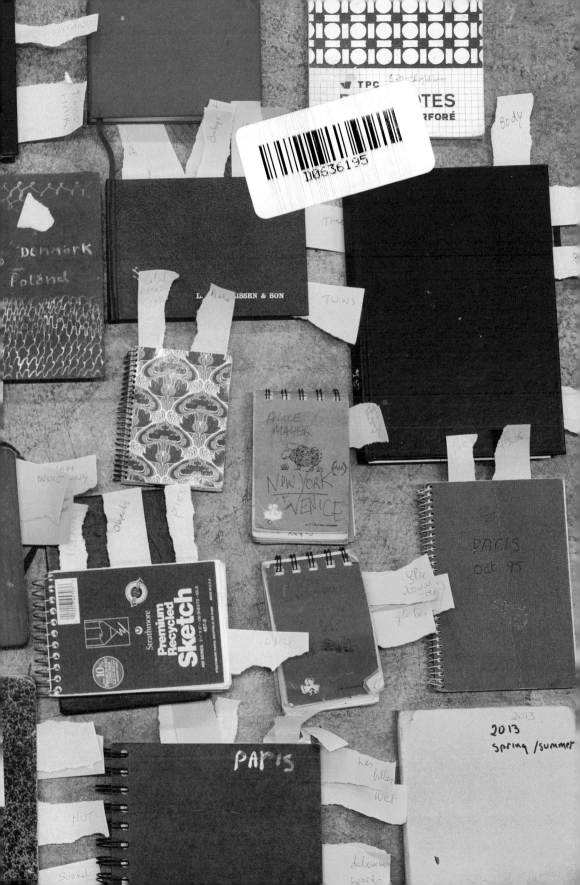

RESERVOIR

Roads Publishing
19–22 Dame Street
Dublin 2
Ireland

www.roads.co

First published 2014

1

Reservoir: Sketchbooks & Selected Works
Alice Maher
Text copyright © Roads Publishing
Design and layout copyright © Roads Publishing
Image copyright © the copyright holders
Design by Conor & David
Printed in Ireland

British Library Cataloguing in Publication Data

A catalogue record for this book is
available from the British Library

978-1-909399-35-8

RESERVOIR

SKETCHBOOKS & SELECTED WORKS

ALICE MAHER

ROADS •

FOREWORD

Whitney Chadwick

In *Reservoir: Sketchbooks & Selected Works*, Alice Maher vividly evokes the ways that drawing, thinking and making are linked in the artist's mind through the conceptual image of the 'reservoir' as a receptacle for both storage and release. Maher's focus on fluidity, and her vision of artistic practice as a state of 'Becoming' (the title chosen for her 2012-3 exhibition at the Irish Museum of Modern Art's temporary space at Earlsfort Terrace in Dublin) are also tied to the processes through which an intangible thought, image or idea is actualised in reality.

Nowhere is this clearer than in the small drawings that are the focus of *Reservoir*. Modest in scale, many of them sketches or simple notations, they reaffirm the presence of the hand, the line, the trace and the gesture as important constituent elements in formations of meaning. They link and encourage resonant dialogue between the subtle and the intimate, the public and the monumental. Evidence of the hand, the line and the trace also resonates in Maher's larger and more fixed installations and sculptures: in images of bundled rope and twigs that mass line into shape, and in coils and falls of human hair formed from an accumulation of filaments so fine as to be almost invisible when viewed singly, to cite just two of many examples.

The feminine – mythic and real – shadows Maher's enterprise. It emerges within a set of contemporary issues that range from constructions of gender and sexuality to representations of history, landscape and identity. Drawing inflects large installations that both signify and deconstruct the power of archetypal femininity – from the seer/sorceress Cassandra to Andromeda, the victim of her own mother's hubris. Signs of human and animal, the organic and the constructed (a luxurious twist of hair, a necklace of lambs' tongues, a series of sculptures) coexist uneasily in a rapacious nature that threatens to overwhelm and erase their legibility.

Meanwhile, the sketchbooks preserve the evidence of intimate encounters through a graphic line that hovers between the visible and the invisible in its evocation of the fragility and humanity of touch. Ranging from loose gestural scribbles to muscular markings, Maher's small drawings embody a fluid process that opens the possibility of multiple interpretations in an unstable terrain that shifts between body and mind, thought and expression, nature and culture, unitary and hybrid form. With their improvisational formats – a few words, a fragment of an object, the formation of a word that trails away to become illegible – the drawings often imply the difficulty of apprehension and permanence, as if what we retain of them is only a trace of some larger reality.

Indeed the sketch (from the Greek *schedios*, something done extemporaneously) has long served artists as a means of recording the ephemeral, capturing an idea for later use, or graphically demonstrating an image or idea without recourse to verisimilitude. It has encouraged quick, loose execution (Richard Tuttle), served as a pictorial travel diary (John Constable), enabled the capture and working out of a preliminary schema for an image or concept (Eva Hesse). In *Reservoir* Maher vividly and elegantly transmutes such historical antecedents into a graphic drawing practice in which the sketch becomes a reservoir, a container, and a conveyor of 'liquid ideas' that ebb, flow and interweave. 'A notebook,' she has said, 'is like a way of thinking.'

Specific drawings capture intimate interactions, and confound our expectations (in *Born Seeing* an attenuated arm traces a tiny image on paper, while a ladder standing next to it tilts into space at an angle that defies the laws of gravity, despite the artist's inclusion of directional arrows). The words 'everything is useful whichever way it's going' appear under the image, without either explaining or illuminating its meaning.

Other drawings pose unanswerable questions about relations between animal and human, the animate and the inanimate, past and present. In one of these a scribbled notation at the bottom of the page identifies *la mujer sierpa* (the serpent woman), an alluring female figure who poses like an ancient and seductive goddess as she offers an egg to one of several serpents that coil out of her headless neck. As the drawings accrue themes emerge, ambiguous situations undermine logic, hybrid forms challenge rational order. Maher's play with the tangible and the intangible, the unique and the hybridised, carries with it a hint of the ever present 'laugh of the Medusa', long believed to shatter the logic that supports dominant forms of cultural order. At the same time the artist puts her faith in a life that ebbs and flows like the tide. 'Joyce never wasted one word,' she wrote beside the serpent/woman; 'He kept everything he wrote and used it in different works. So going back to use imagery from sketchbooks is being non-wasteful.' In Maher's drawings the hand's trace remains and nothing is wasted.

INTRODUCTION
Alice Maher

Using a sketchbook is not simply about coming up with ideas. It is rather a process of letting ideas flow back and forth, round and round each other until a kind of current is created, a vortex out of which comes the beginning of an artwork. If you have described something, whether it be in writing or drawing, it never leaves your consciousness. It is stored away, waiting to be drawn to the surface of that great pool, the reservoir of the self.

I have kept sketchbooks of varying sizes for about thirty years now. I draw, write, record with whatever material is at hand: ink, pencil, pen, gouache. Like scratching an itch, it's more of a reflex than a planned act. Sometimes I'll simply make a mark, any mark, and follow it until it 'becomes' itself. Other times I'll make a note of an unusual shape that attracts me while I look out a window, I'll jot down some unusual overheard phrase, or I'll list the names of all the townlands through which the bus passes. I don't use sketchbooks to plan things or to project what a finished work should look like, I use them as the freewheeling workshop of the mind, where passing fancies, objects, thoughts, and quotes all go into the soup. And that liquid of the imagination is added to and expanded, distilled and digested, over years and years. It never dries up and it never stops boiling.

I was always interested in the marginal areas of communication and knowledge, in hearsay, half-truths and fables, the edges of speech, the wandering mind. The sketchbook is the perfect place for the mind to wander with freedom from censor and judgement. It is the pool in which thousands of images and ideas float freely, rubbish and gems together, bumping into each other, some surfacing, others staying in the depths for years, waiting to be remembered.

But memory is a funny thing. Mnemosyne was the goddess of memory and the inventor of language, one of the Titans and mother to all the muses, yet her name is almost entirely forgotten in the pantheon of gods that inhabit our western classical history. I have made many artworks around the subject of memory and I am convinced that it can work in both directions; that it is not simply a backward-looking street, but also a road that leads ahead, into the future past, like a wormhole in space. It is a continuous joy to me to suddenly find in a sketchbook of 1995, for instance, a shape, a phrase, or even a sound that is just about to re-emerge in a film in 2012. 'There it is,' I say to myself, 'it was there all along.' And because the same shapes, forms and concerns seem to recur again and again it would seem that nothing is actually new, but by describing it to yourself, you are simply finding what was already sought. So perhaps it's the shock of recognition that compels me to draw something, not its novelty or strangeness.

The final piece of the creative jigsaw is of course the meeting of artwork with its audience. It is the spectator who brings art into contact with the external world by engaging with it, interpreting it and bringing their own imagination into the mix. This is how the artist's reservoir remains continually full, because the public showing of the work and the engagement of other people feeds back into that creative current, giving it new life and a future beyond itself.

One of Ireland's great writers, Mary Lavin, was criticised for the absence of plot in her work: the fact that her stories had no definable beginning, middle or end. She replied that this was because life itself has no plot. She preferred to think of her writings as 'an arrow in flight'. This image fits perfectly into Luce Irigaray's theory of '*l'écriture féminine*': the proposal that women often

use language differently, employing a style that explodes established forms of expression and denies conclusive reading. So I would like to conclude with an ode to inconclusiveness, and to borrow Mary Lavin's great image of the arrow in flight to describe my wishes for my own work: that it should be forever aiming towards something, suspended, becoming. That the reservoir should be always full but never still, that the channels in and out of it remain forever open, filling and emptying in equal measure.

SKETCHBOOKS 1986—2012

everything in the world has a spirit,
which is released by its sound...

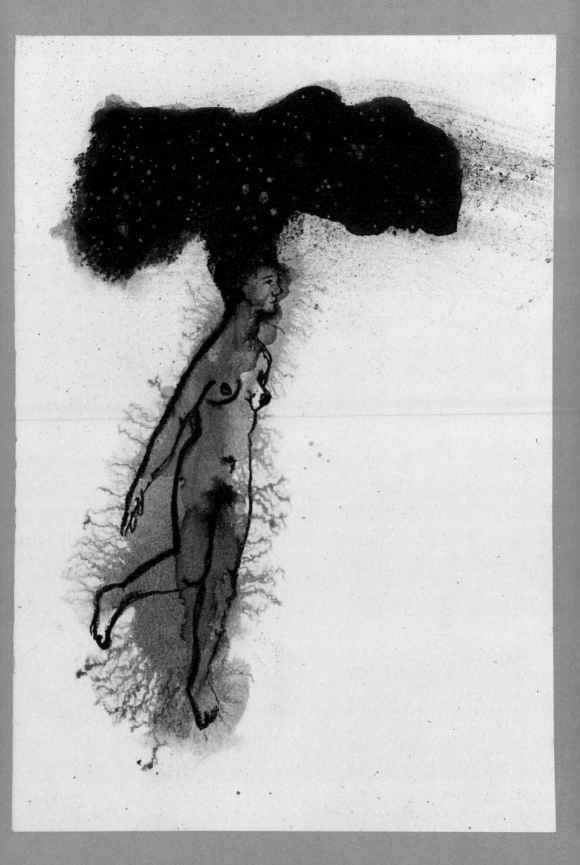

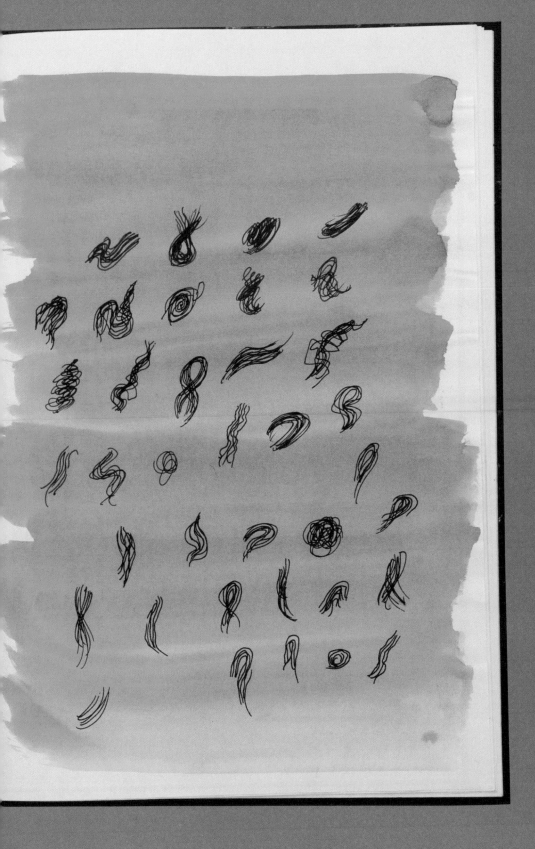

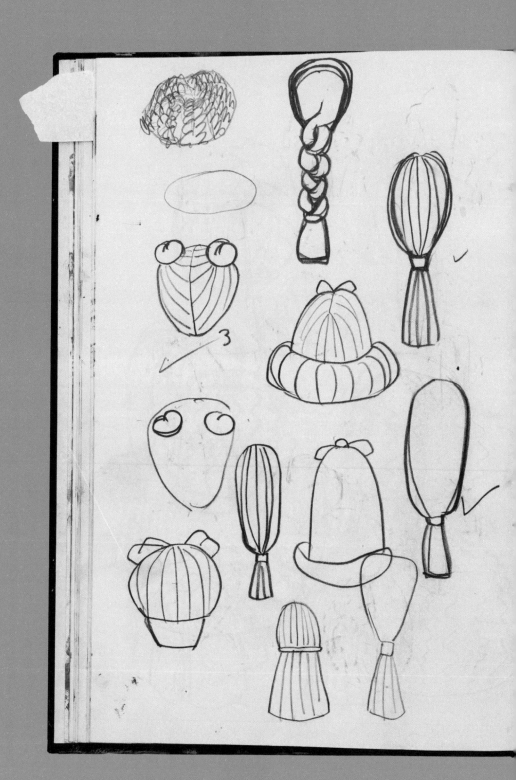

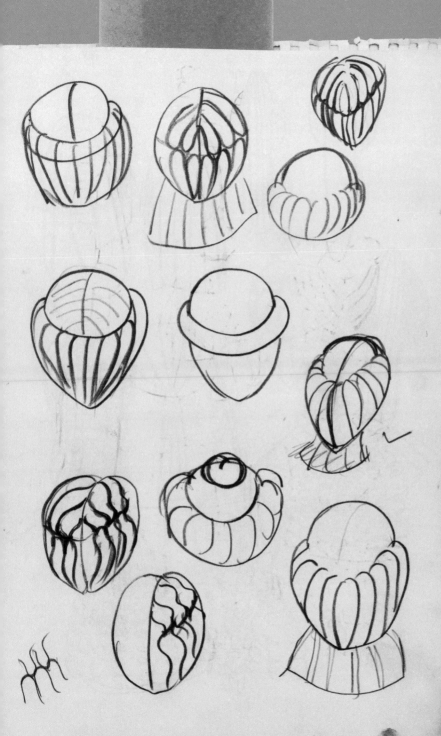

Field
hahri...
pieces

SKIRTS

Hea
W

"male
male
male

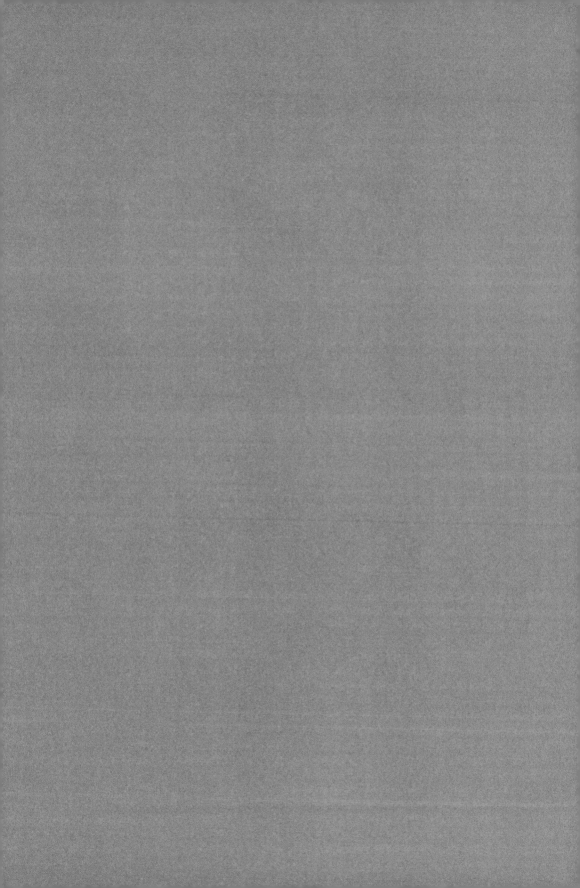

EURIDYCE

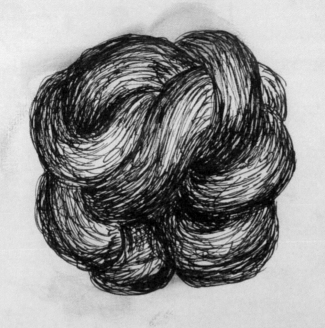

BERENICE

PERSEPHONE

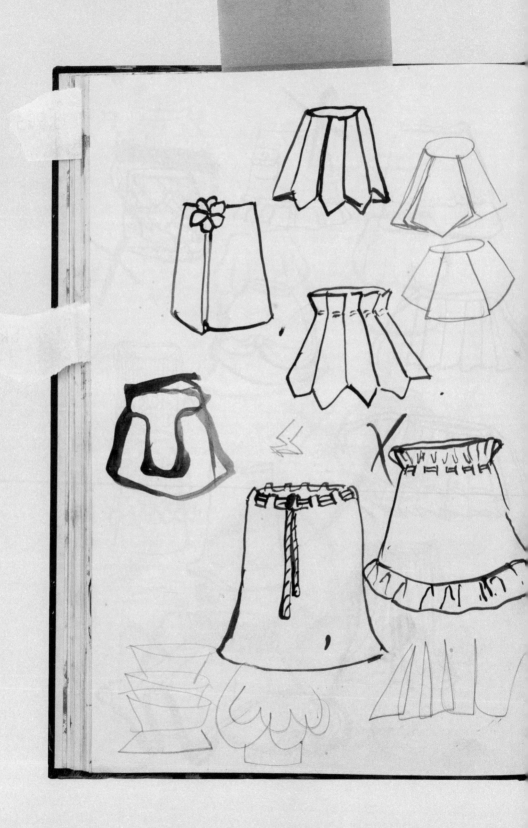

hairstyle

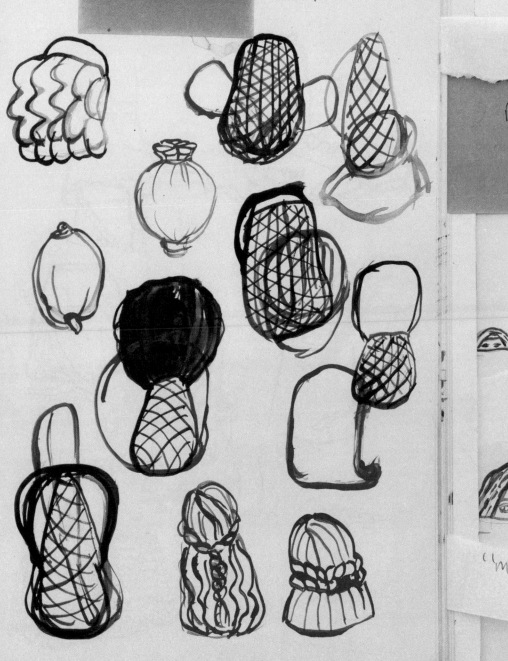

Field
Labrin
pieces

He
L

"male
male
male

Foot

CRY
ING.

Bed

WAIST

Sleepleasure

Medusa?.

Girl
Ph...

Dancin
gue
plac...

Pillo
+
sta...

FEW
SH...

SHIRT

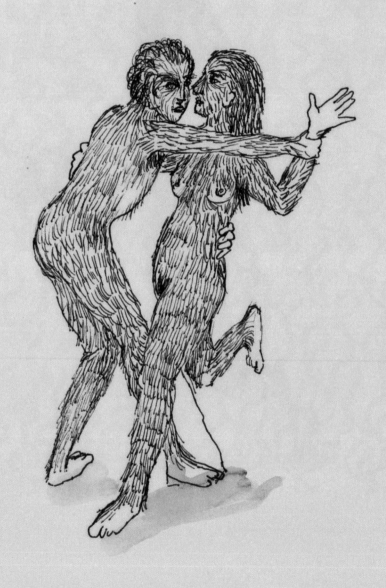

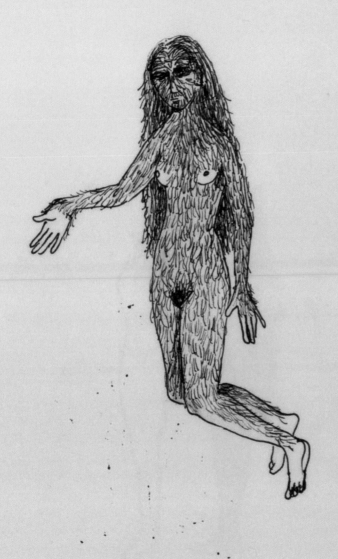

Gods little helper

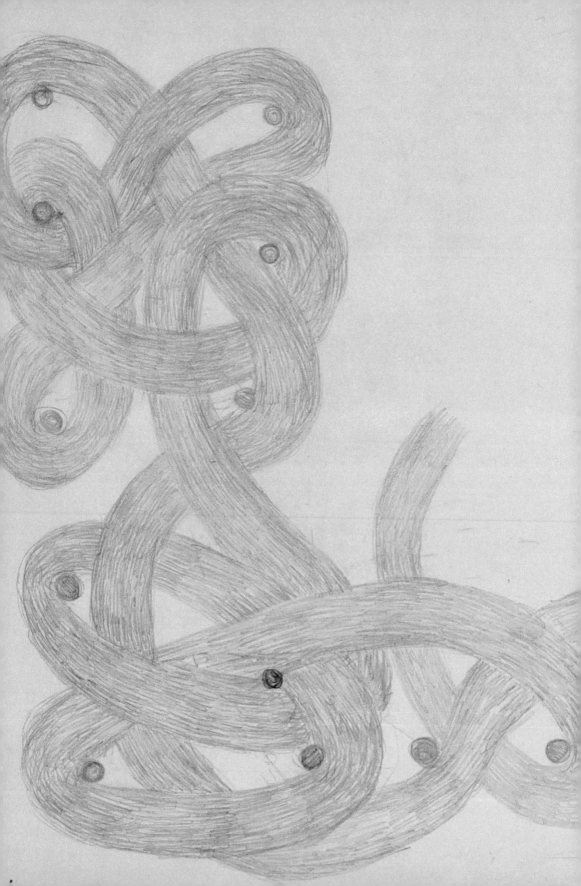

nothing is ever the same,
there is only difference,
copies are always new,
e'thing is constantly changing
Reality is a becoming, not a being

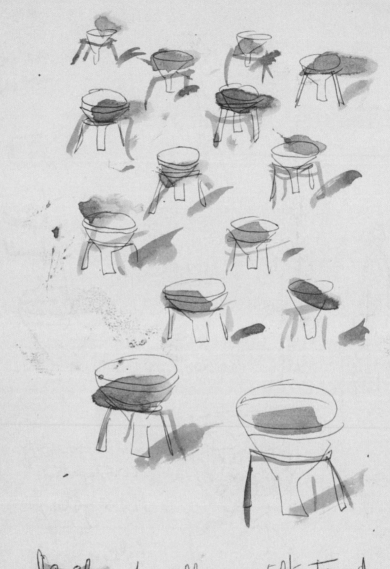

large funnels on stilts tripods.

filled with
HAR

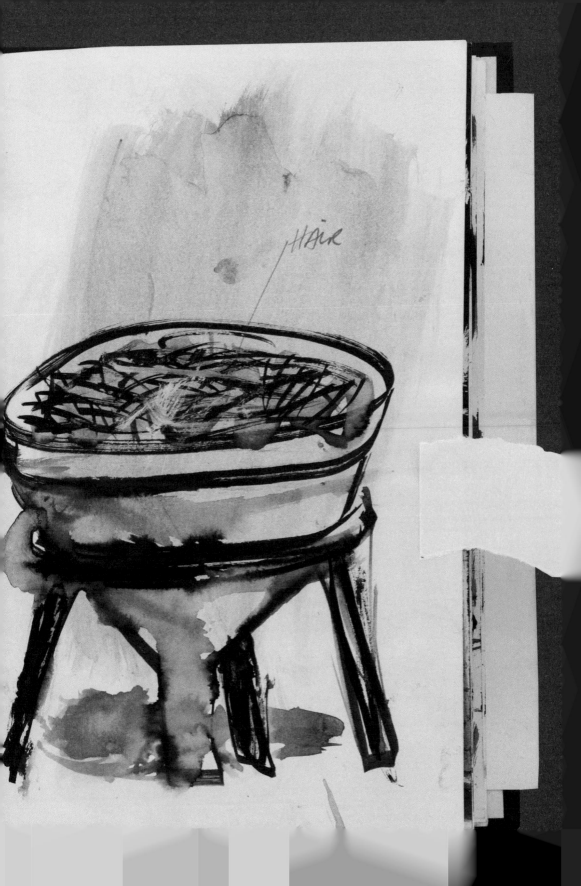

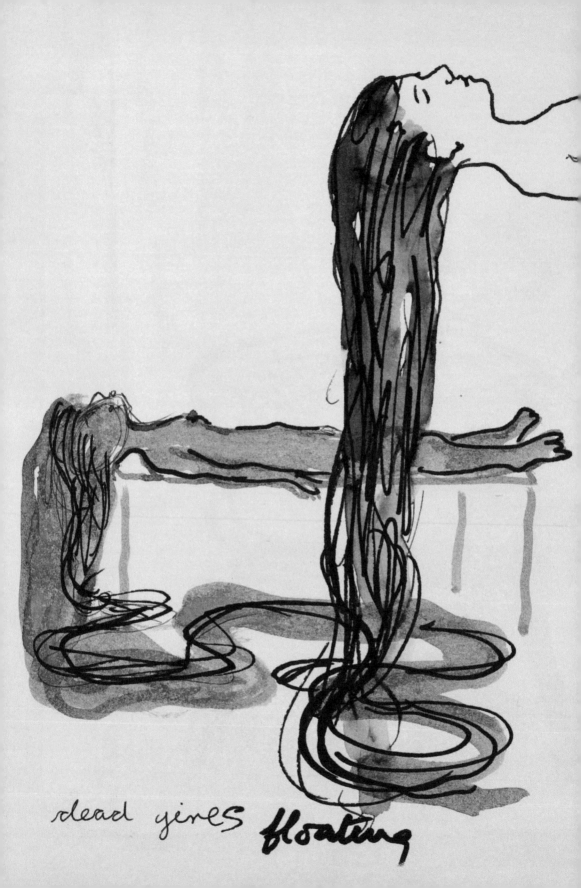

dead gires floating

born seeing.

everything is useful,
whichever way it's going.

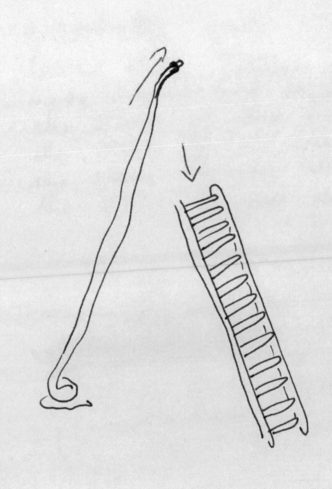

cleaning — washing
weeding — scraping
cooking — boiling
reducing — simmering
straining — pouring

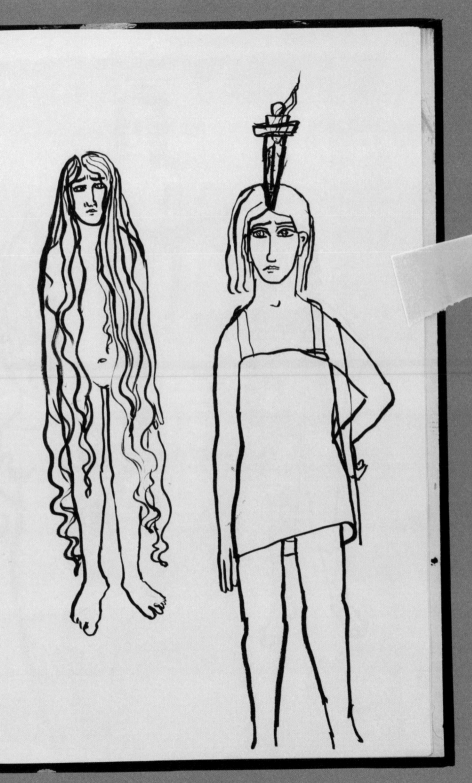

at the centre,
ariadne's ball of string
(bronze)
2'

Field
Labyrin
pieces

"male
male
male

DOUBLE MAZE

Bachelard

"the ecstasy of the newness of the image"

the poetic image is not an echo of the past. On
the contrary: through the brilliance of an image,
the distant past resounds with echoes, and it is
hard to know at what depths these echoes will
reverberate and die away. Because of its novelty and
its action, the poetic image has an entity and
a dynamism of its own; it is referable to a
direct _ontology_ .

psychoanalysis cannot really explain the wholly
unexpected nature of the new image, anymore than
it can explain the attraction that it holds
for a mind that is foreign to the process of
its creation.

image _before_ thought ?

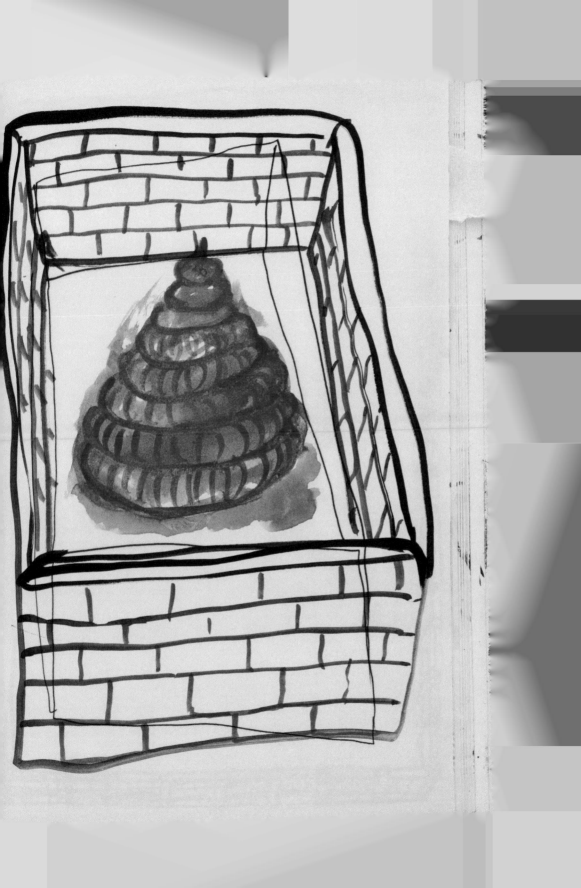

the mound of the
hostages.

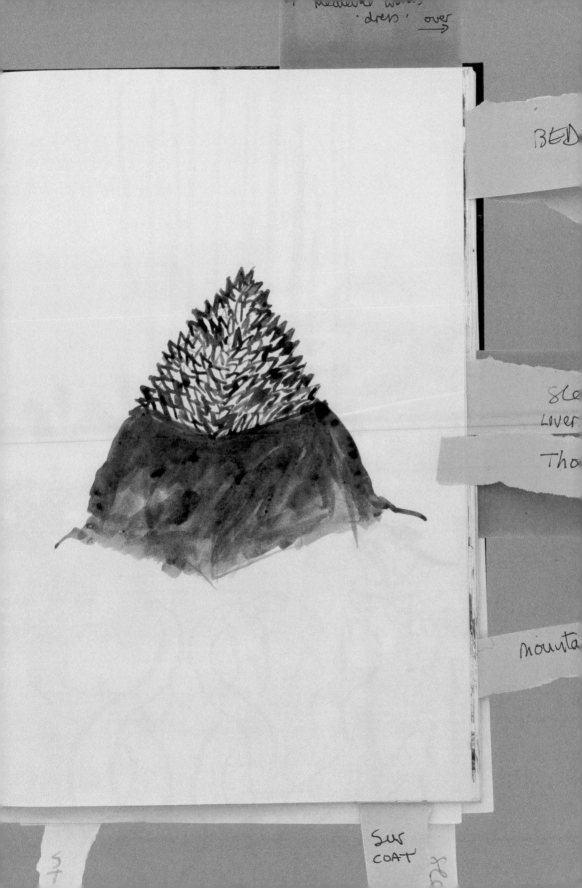

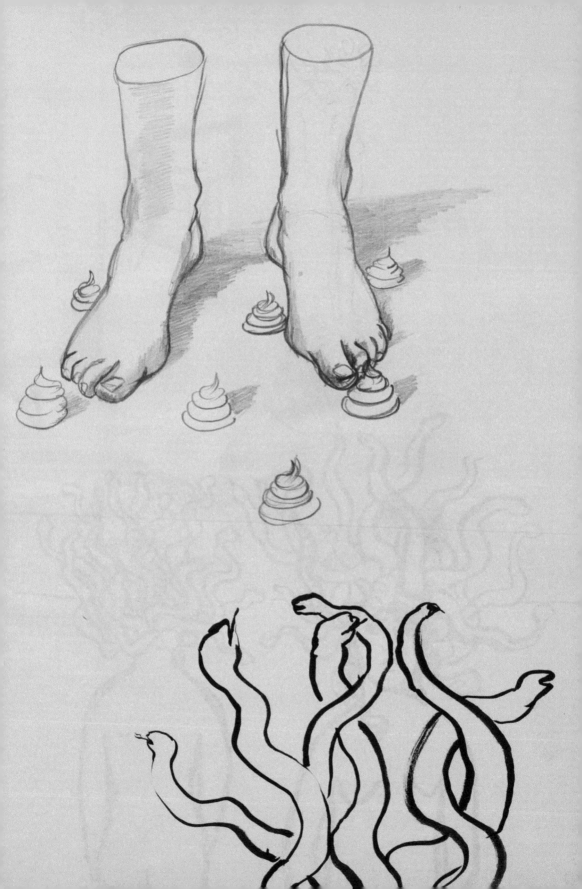

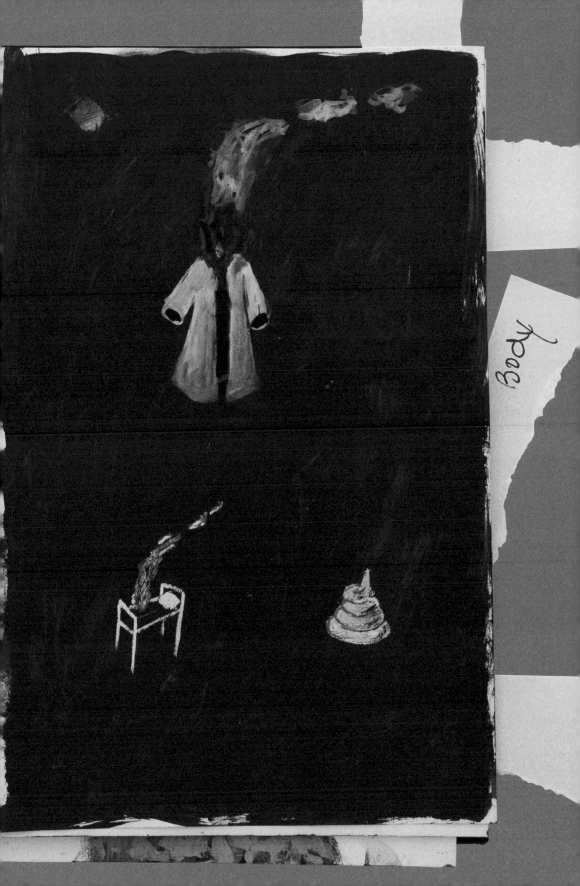

Body

sept. 14

On the Belfast Dublin train leaving Belfast behind with relief. Just a week ago a man got on a train, sat opposite another for some time then took out guns and killed him. He was a member of the Ulster clubs. Yet on this train the 2 men wheeling the tea-trolly enter singing "if ya go will you send back a letter from America?...". There is such a hysterical relief that everyone is infected. The joy of normality goes through the train like a breeze. So that when the locomotive breaks down in Malahide no complaints are heard but people almost enjoy the old-style delay and a man quips "are you right there Michael are ye right....". Then we slowly steal our way creaking into Connolly station.

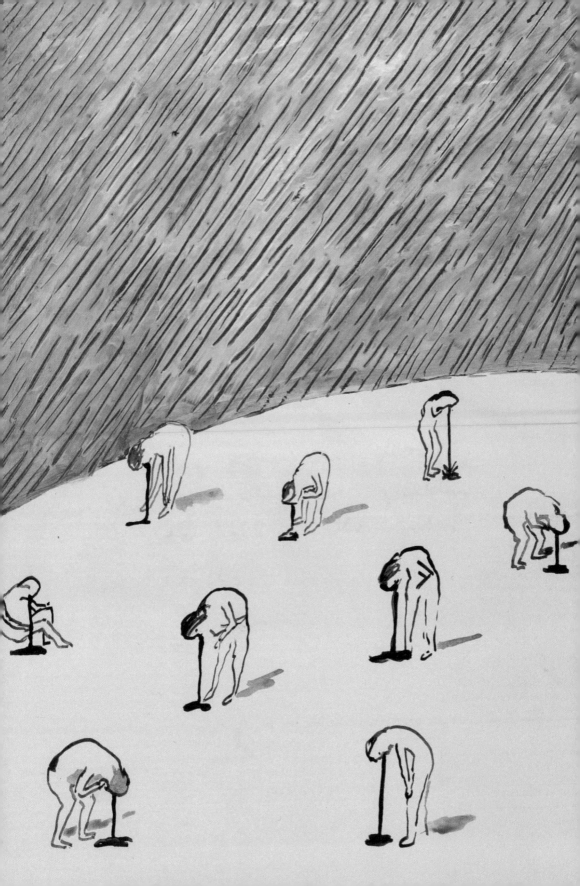

coughing up a thorn

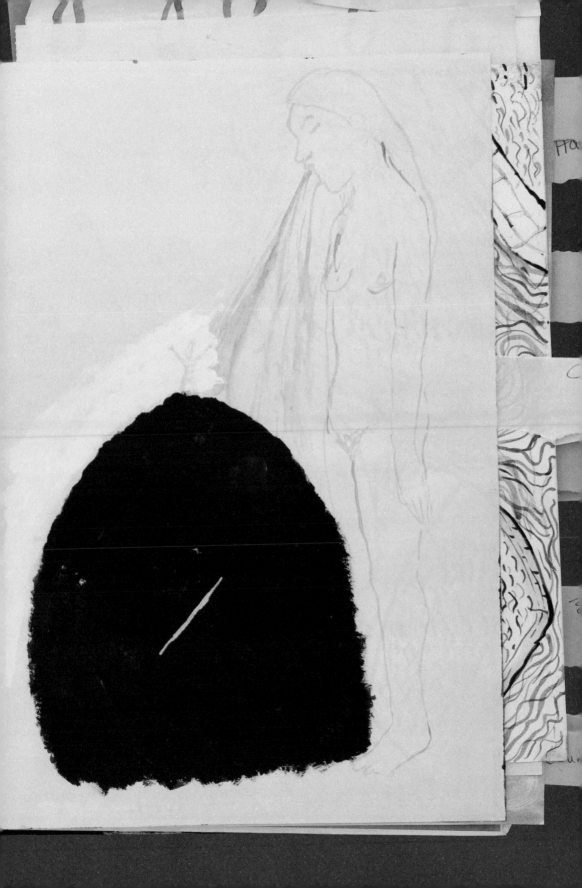

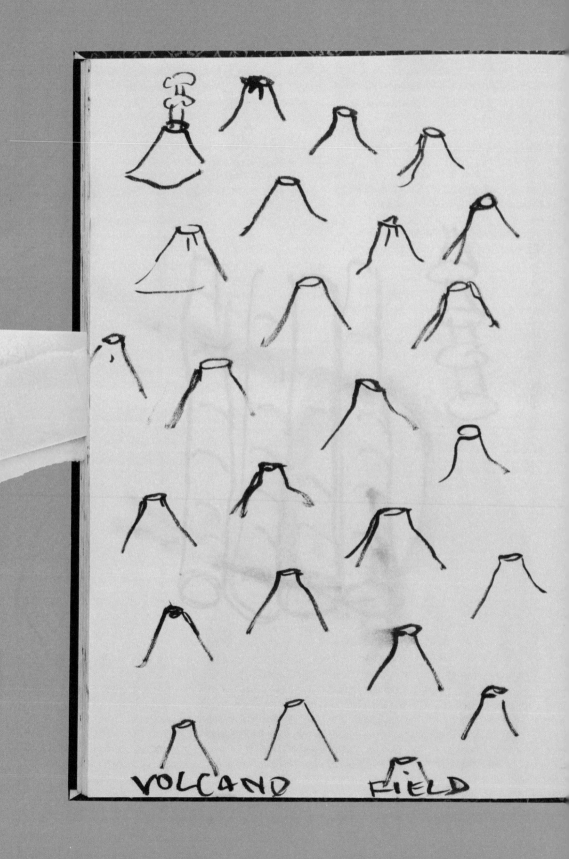

VOLCANO FIELD

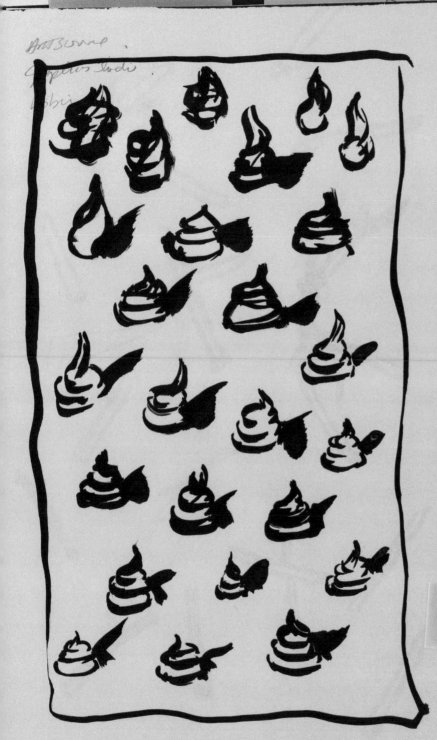

DOUBT –

involve with this word. and
is convinced somehow that
I should be in the title of
my book. the doubt? or
the girl who had a doubt
Doubting girl
— — — — —

CALHAME
DROMOSE LOWER
KNOCKBRACK
CONVOY
STRANDRLAR

MEENGLASS
GOLAND
BARRESMORE GAP

LEGHAWNRY
DROMLONGHAR

A journey from Dunfanaghy to Claremorris

TULLYEASL
LAGHEY
RAGHLY
Streegah
RAHABerna
Markree
Temple House
(eagles flying)

Knocknashee
MUCKELTY
Curry
Curryfule
Broher
Lurga
KiLmoVEE
Carrowbeg
CLOGhvoley
Taber
Shanaghvera
cloondace
BALLyHOWLy
BEKAN

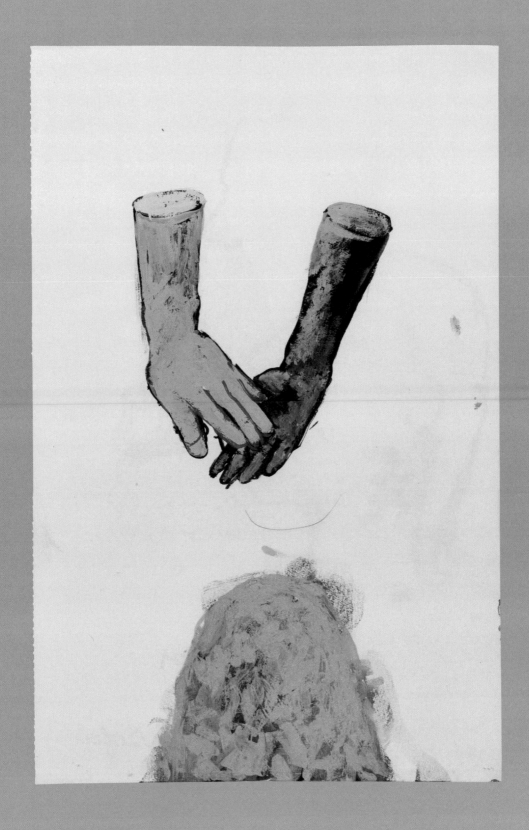

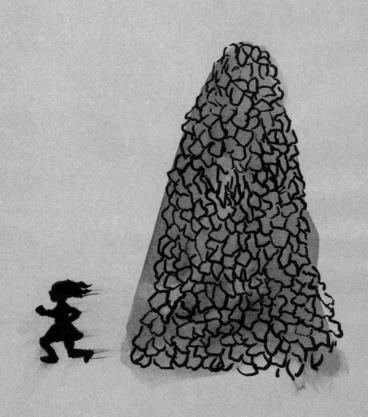

running away from
a bunch of rettles

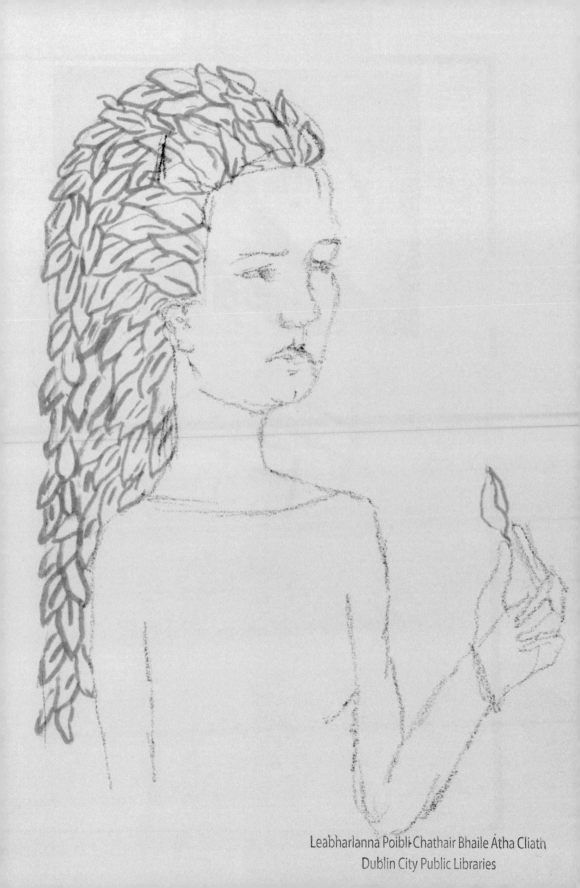

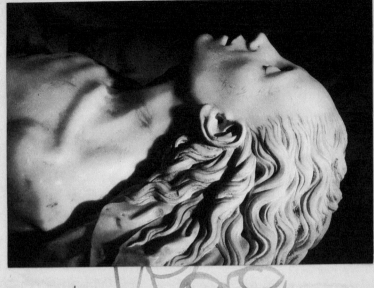

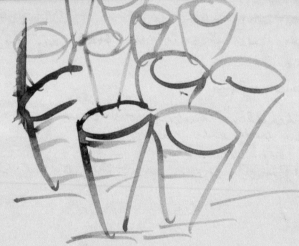

the piercing memory

l'oublie t'enveloppe dans ~~sa nuit~~ nuit.

mowsthous

Cassandra

Founto

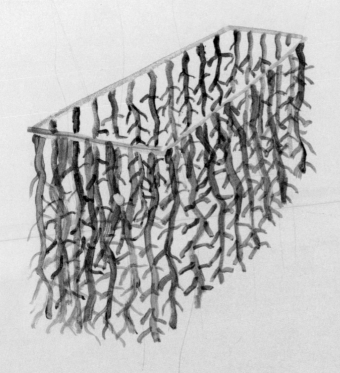

AM

the imagination of the body.
textural memory of ~~the~~ nature, the country.

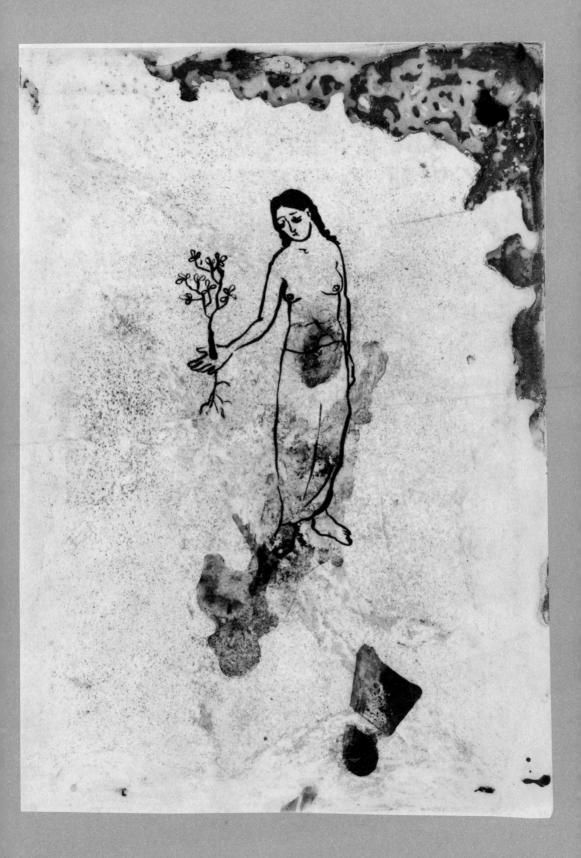

lit de parade (receive visitors)

lit de travail

lit de justice

lit de glace (mirrored)

lit d'auge (canopied)

lit clos

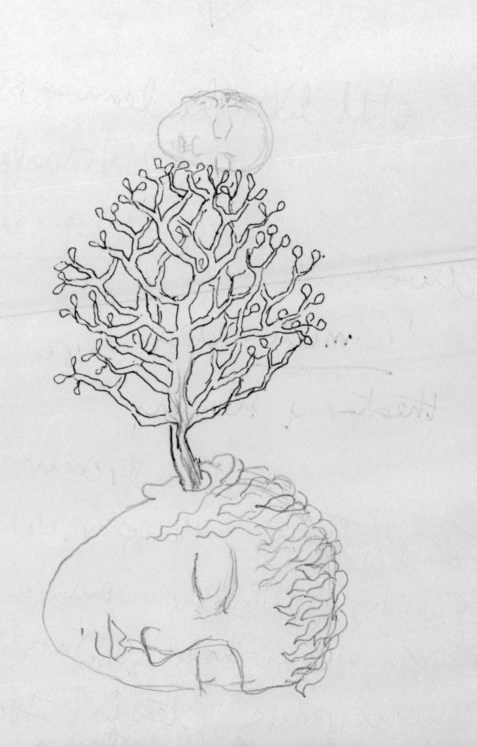

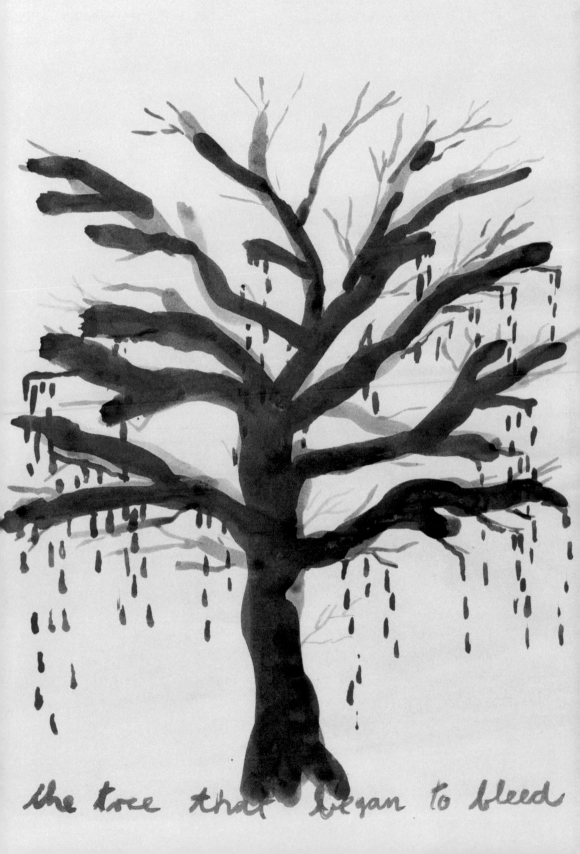

the tree that began to bleed

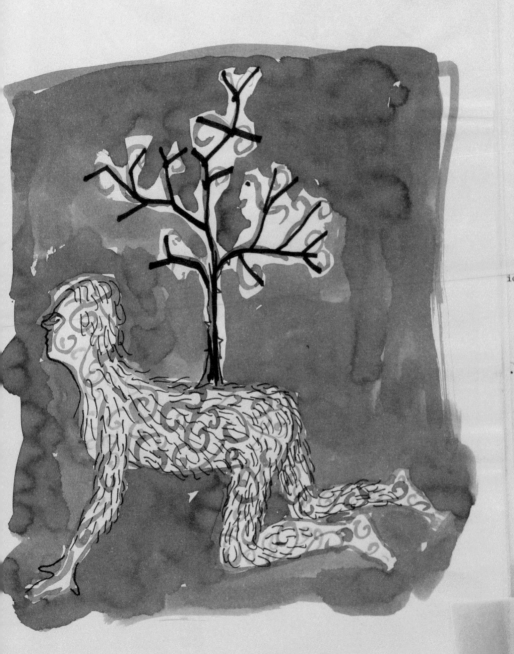

the tree woman

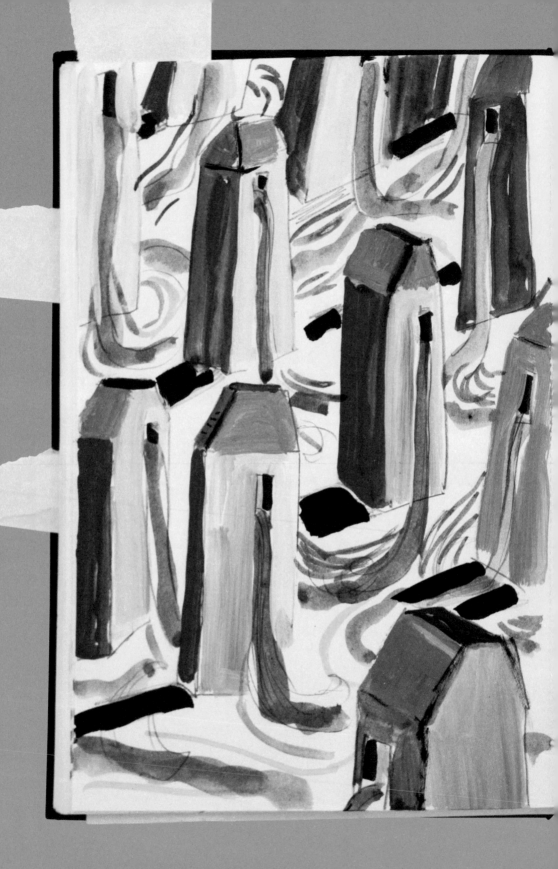

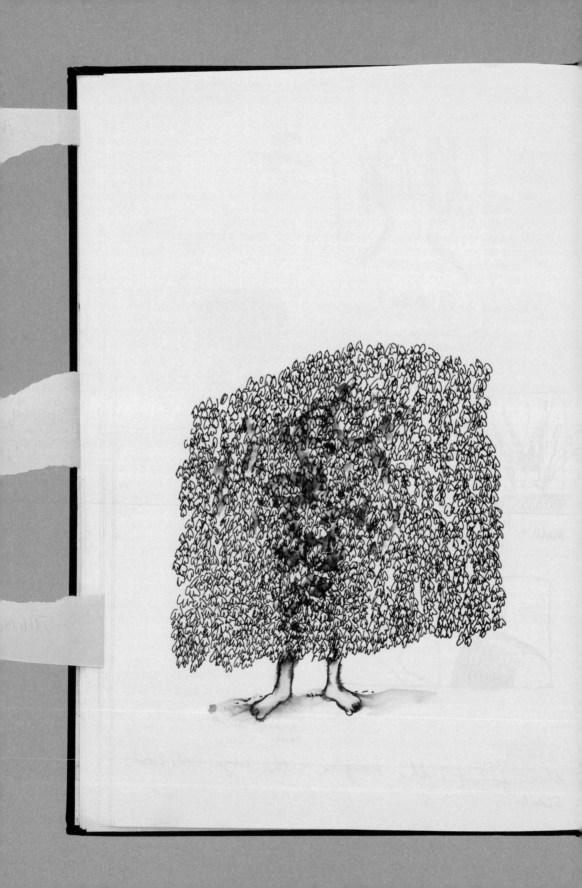

foliage

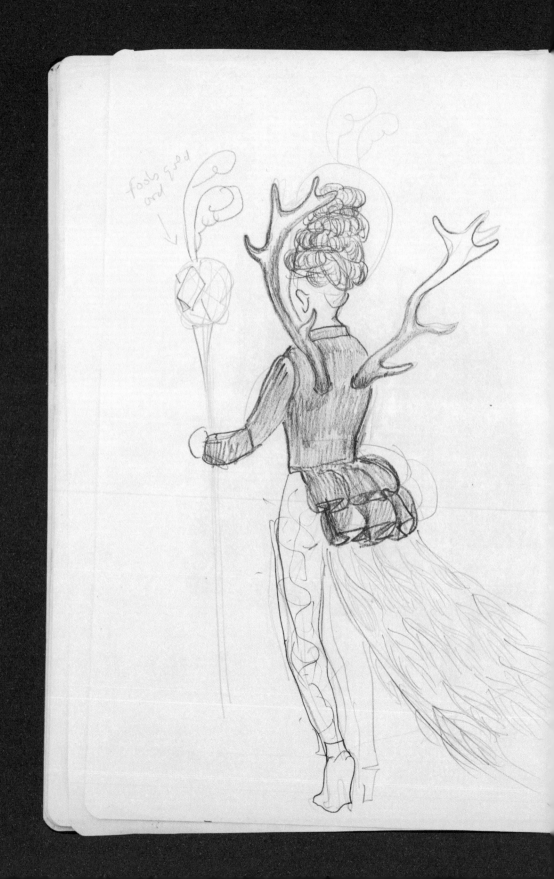

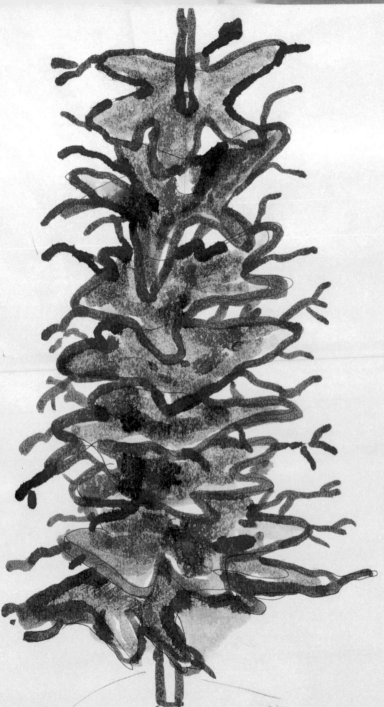

THE DEVIL'S SPINE

small space

BIG IMAGINATION

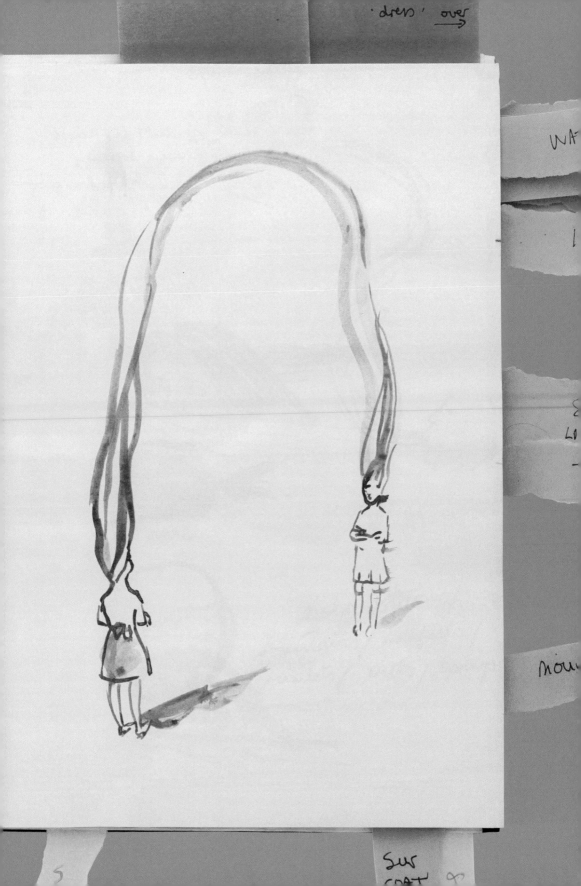

WA

SUR
COAT

Architects Rack
for drawings
hanging

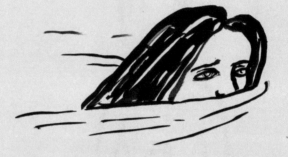

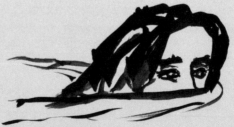

the slippery ~~not~~ touch of skin and liquid
water made flesh

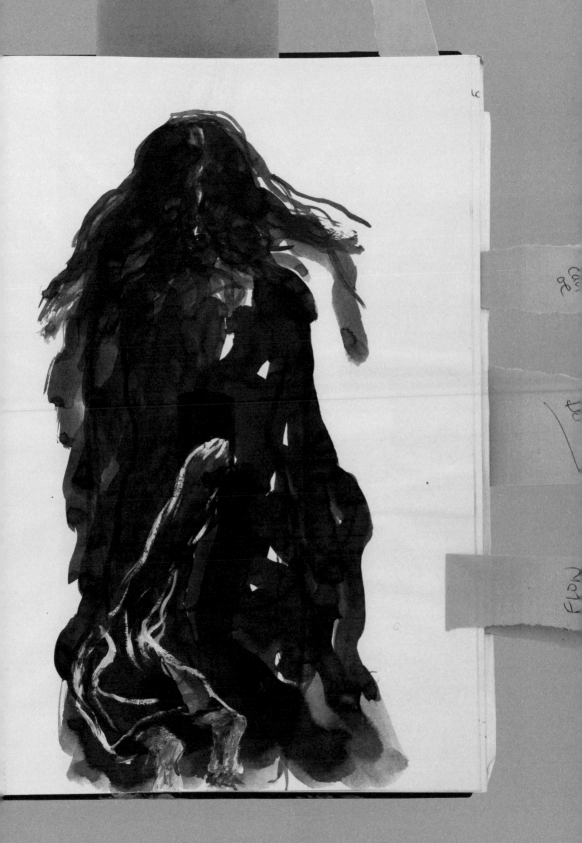

The white fountain

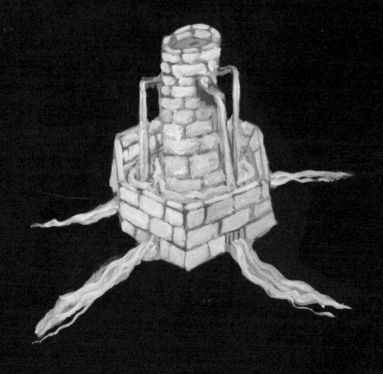

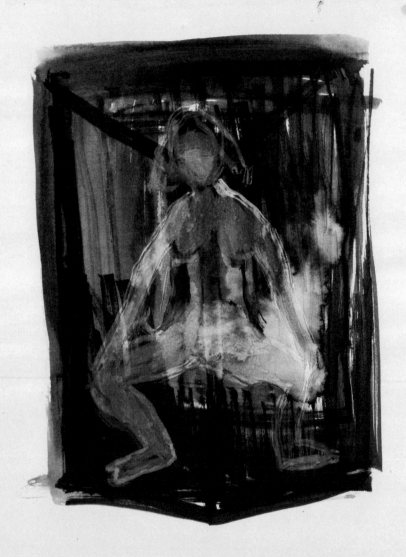

Girl squatting in a geometric shape

the room of thin and fat hair:
la fièvre

BARRAMUNDI

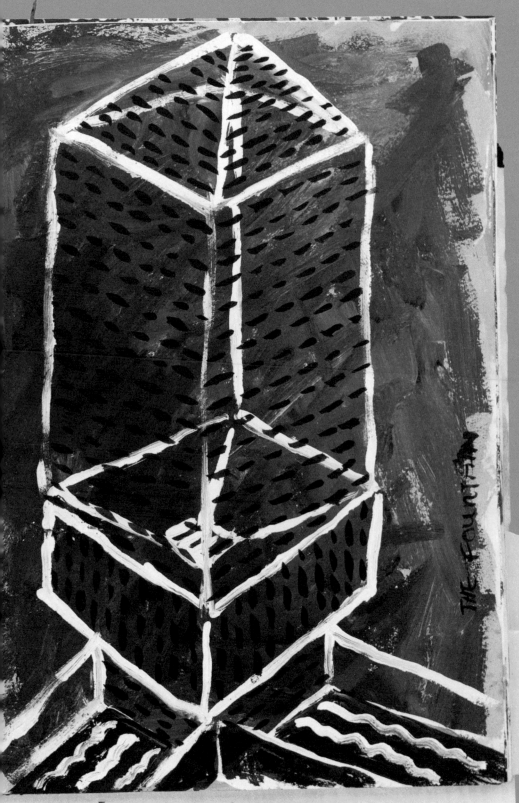

THE FOUNTAIN

MINGARA Club.

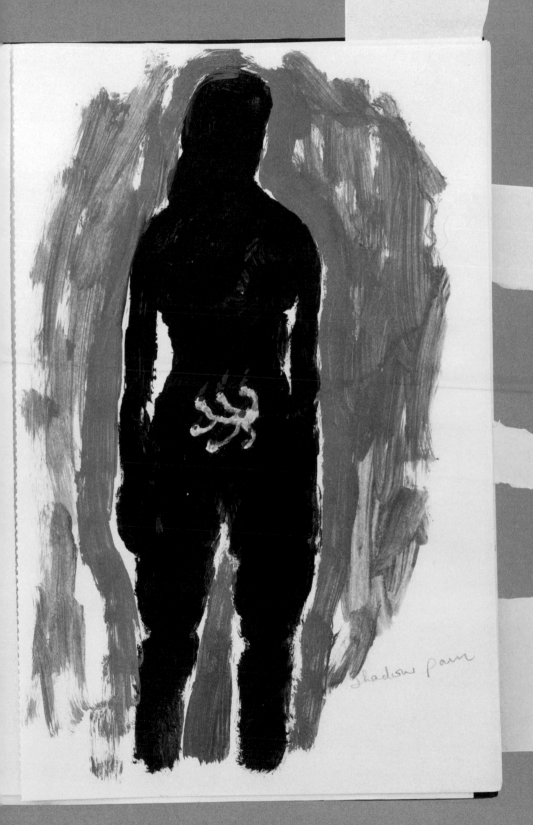

shadow pain

Sleeping with snails

At their night ~~crawling~~ leave silver trails
that are a reflection of our own ~~life~~
journeys in ~~dreams~~
which are like the ~~ephemeral~~ memory trails
~~left by the memories~~ of our own night
~~journeys~~ wanderings in dreams.
They ~~forage~~ round in the undergrowth while
our subconscious wanderings play underneath
the ~~roots~~ and leaves of our lives.

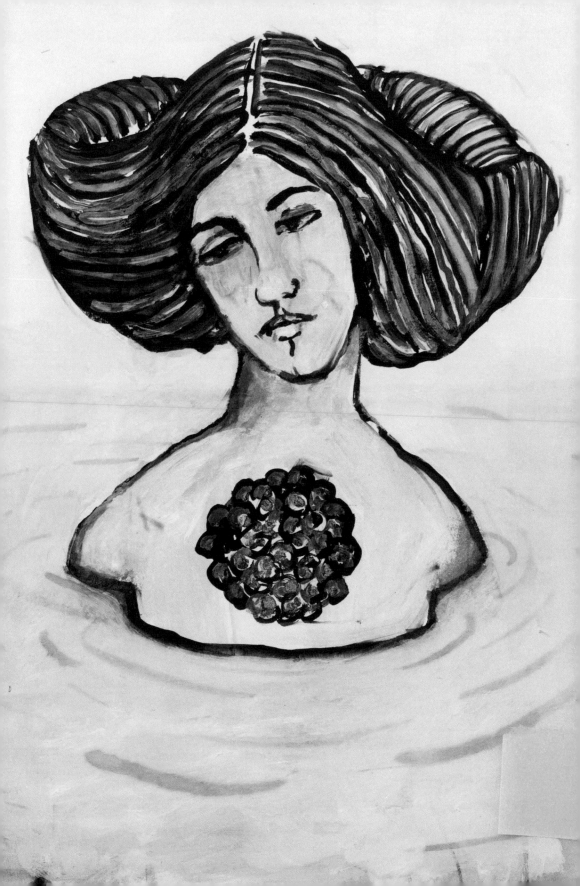

HIGH LOOM SOAR

 Babel -
 Stoa - covered columns.
 PASS
 ┌────────┐
 │ Pillar │
 ├────────┤
 │ Tower │ - turret _ Fort
 └────────┘

 6th SPEAR.
 ───
 8 BOAT Quarter ┌──────┐
 TRIP. │ KEEP.│
 ON FORT └──────┘
 stir obelisk.

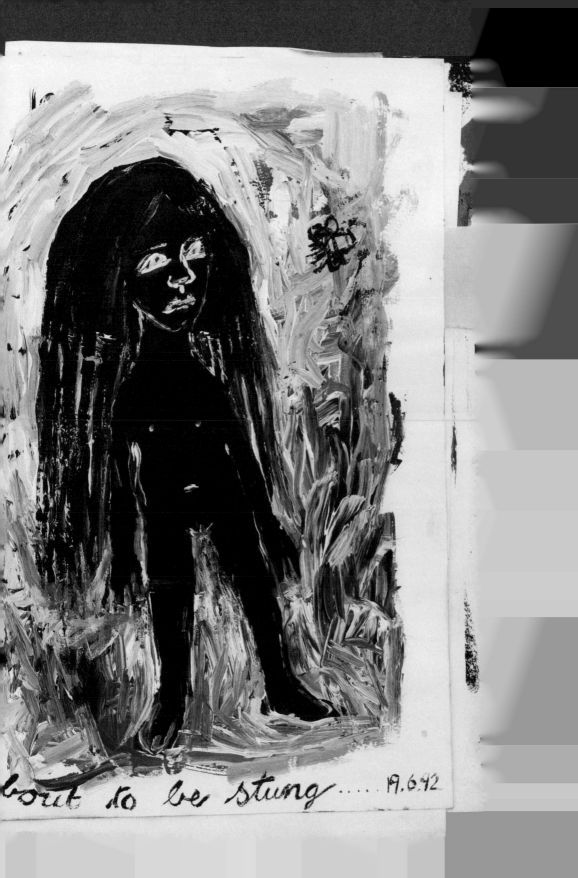

bout to be stung......19.6.92

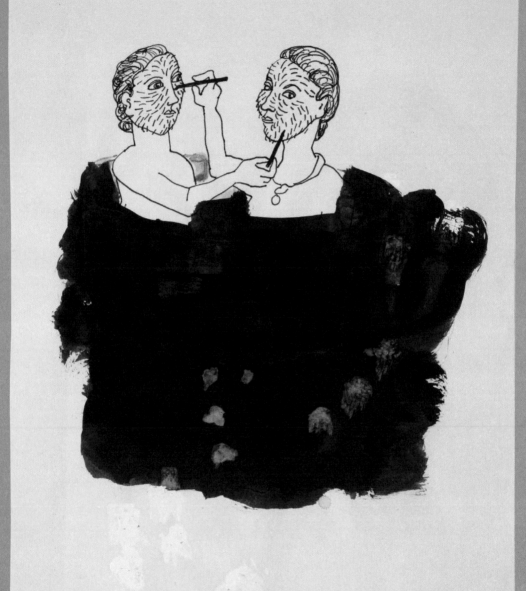

the feral sisters

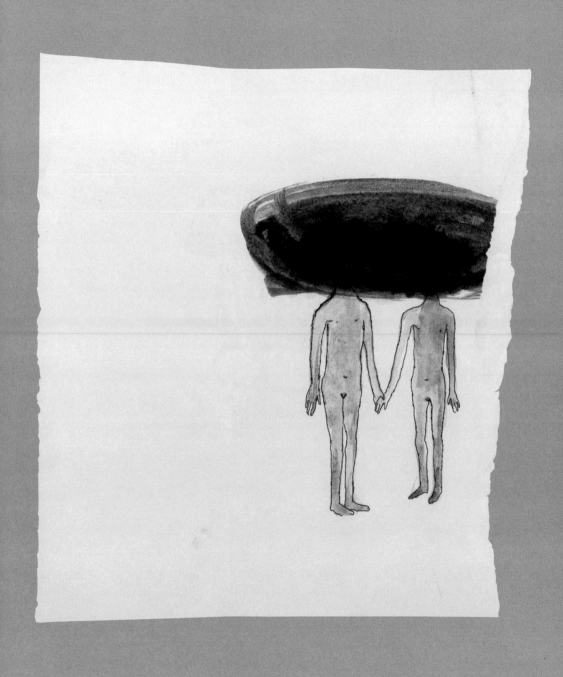

the bottom of things
the sides of things
~~the~~ up and down of things

pointing
clothing
hair
fountain, whirlpool,
bandage, bangel,
cushion, button, belt,
ceinture, knot
bits and pieces

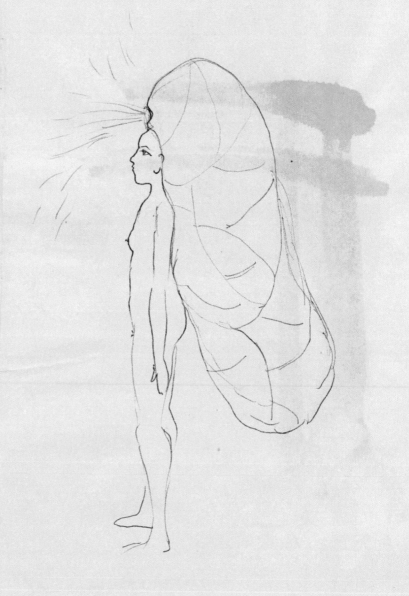

THE Burden of emotion

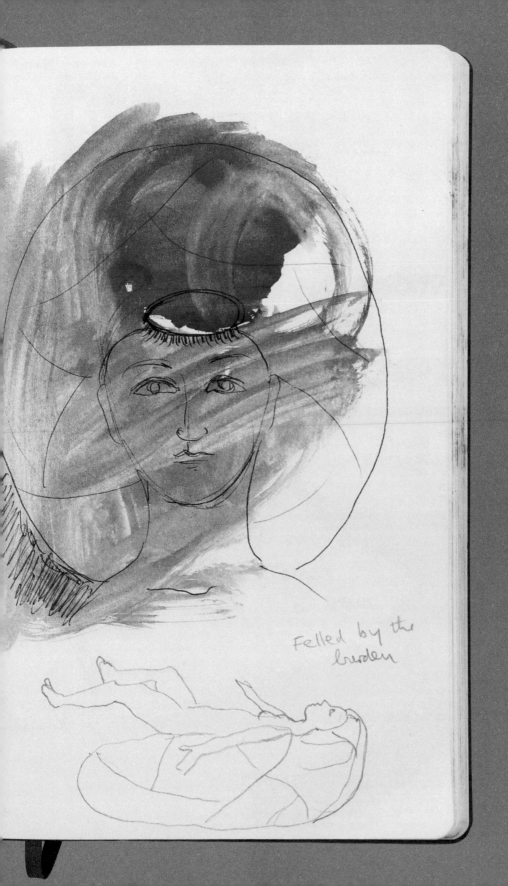

Felled by the
burden

Joyce never ~~never~~ wasted one <u>word</u>. he
kept everything he wrote and used it
all in different works. So going back
to use imagery from sketch books is
being non-wasteful.

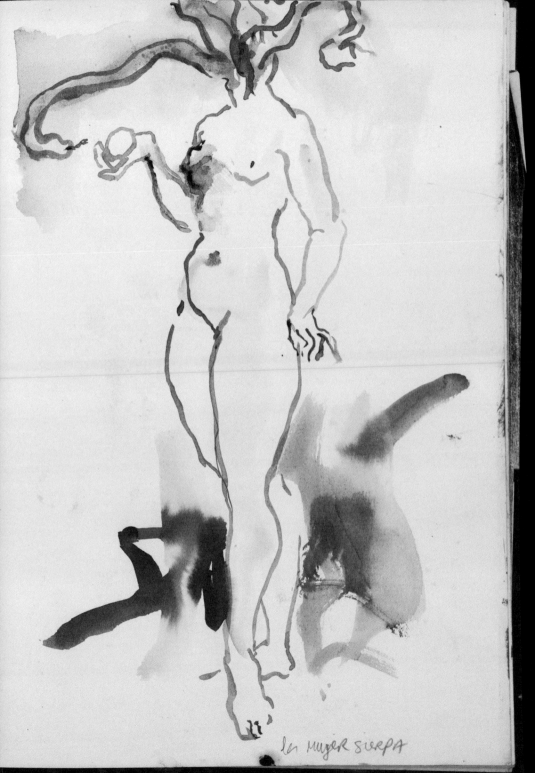

la muger suerpa

16..8.02 Weekend

checking bed's ice build up. I've actually come
to like it with _less_ ice rather than more
now when you can see the piping snaking around
u'neath & see the frost patterns. Going to
time it to last 9 has then cut out & defrost.

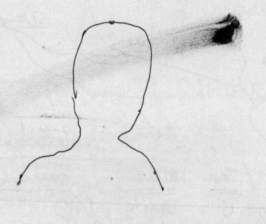

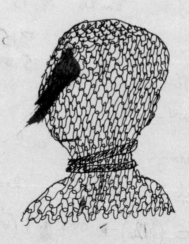

chainmail dress or knitting my grandmother

POI
TONG
INTEST

+ Medieval words
'dress' over →

The necklace of tongues

shadow
clouds

clouds on 18.10.99

BE

SL
LOVE

TA

mou

SUR
COAT

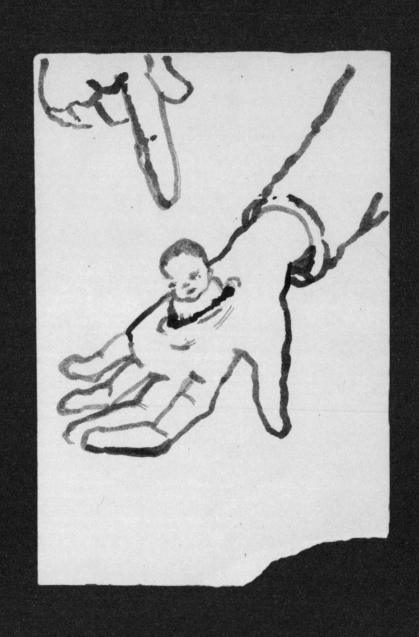

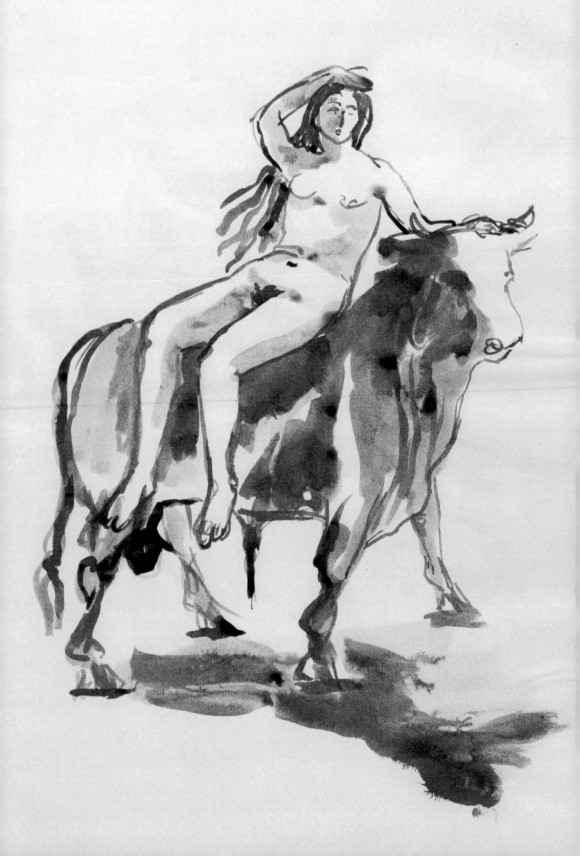

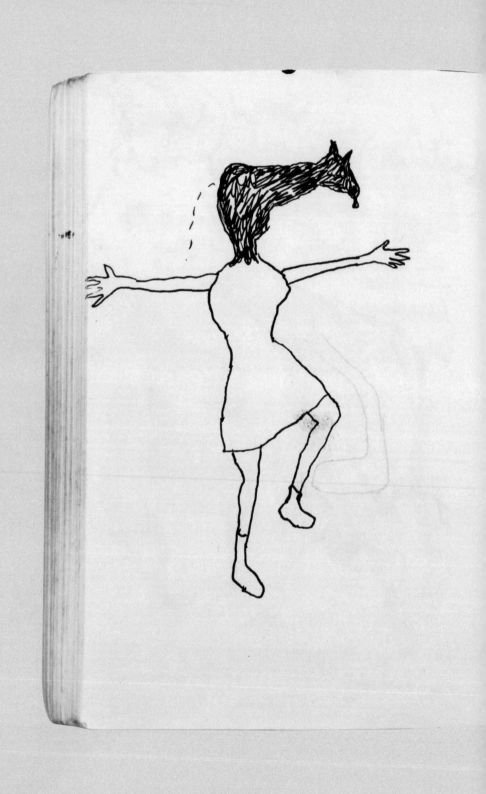

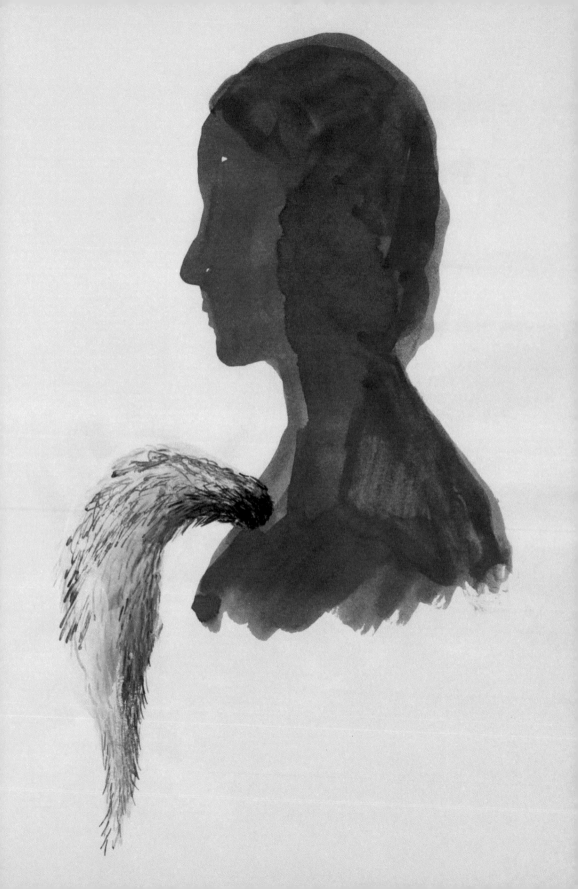

woman with foxtail for a heart

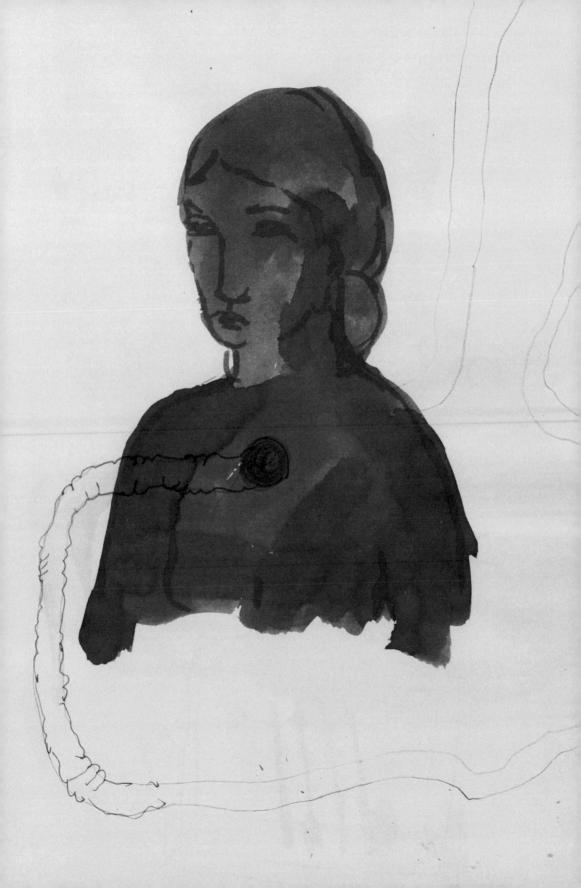

STILLNESS

STILLNESS

STILLNESS

STILLNESS

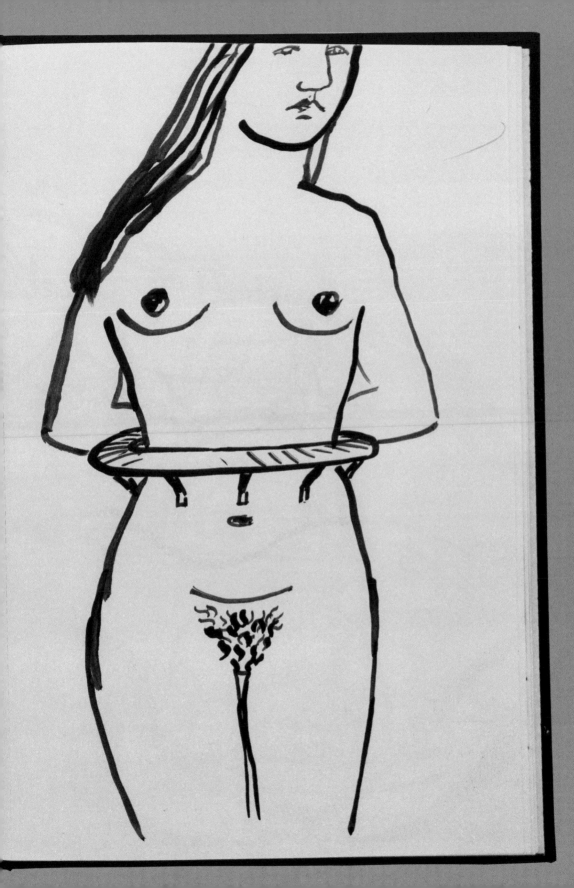

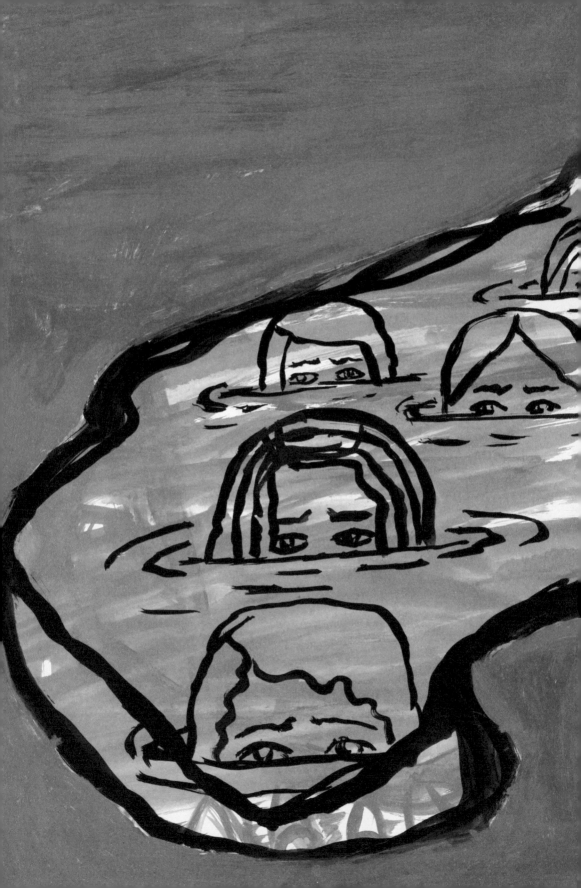

shame y disobedience

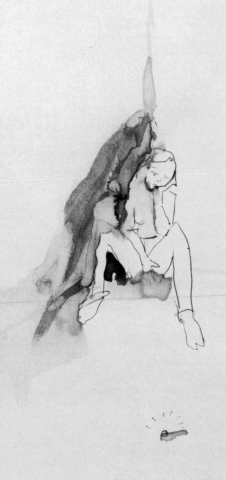

the princess addressed by the pea.

mouth city

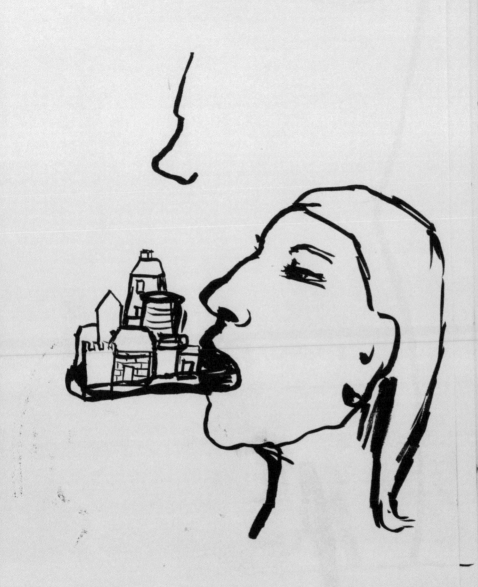

navel

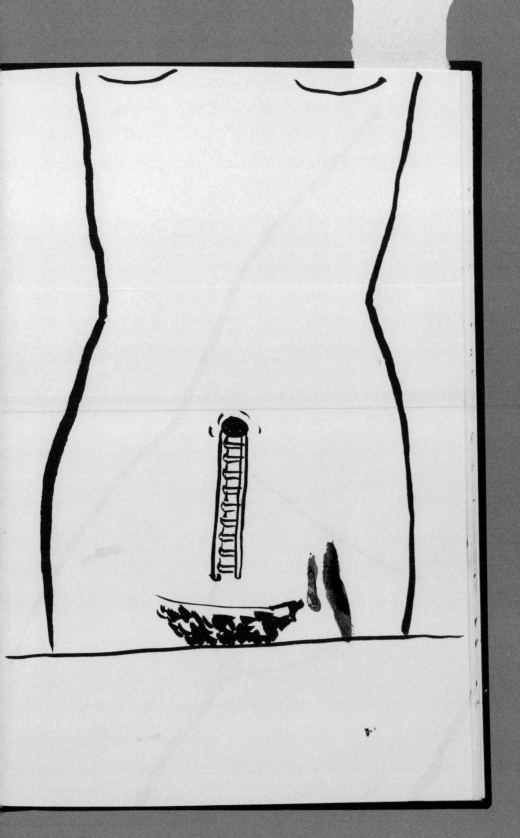

SELECTED WORKS 1992—2012

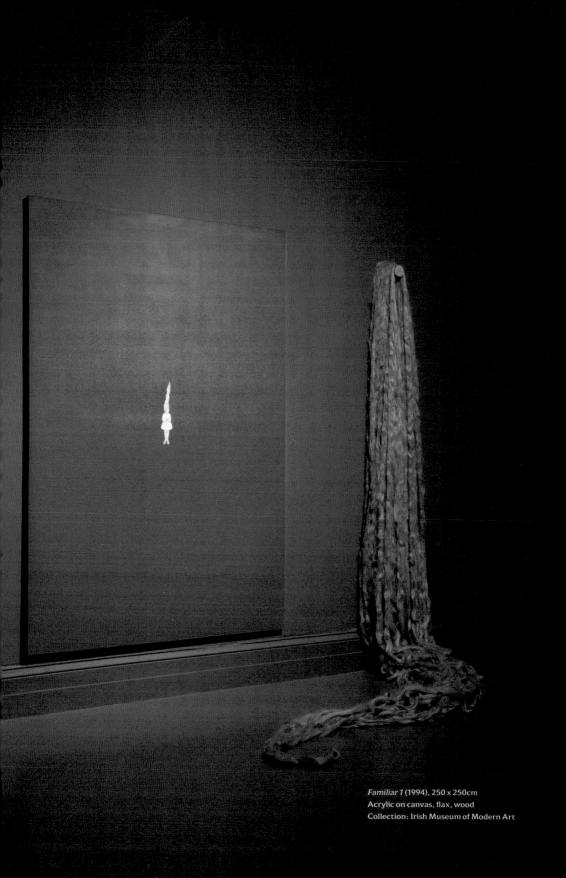

Familiar 1 (1994), 250 x 250cm
Acrylic on canvas, flax, wood
Collection: Irish Museum of Modern Art

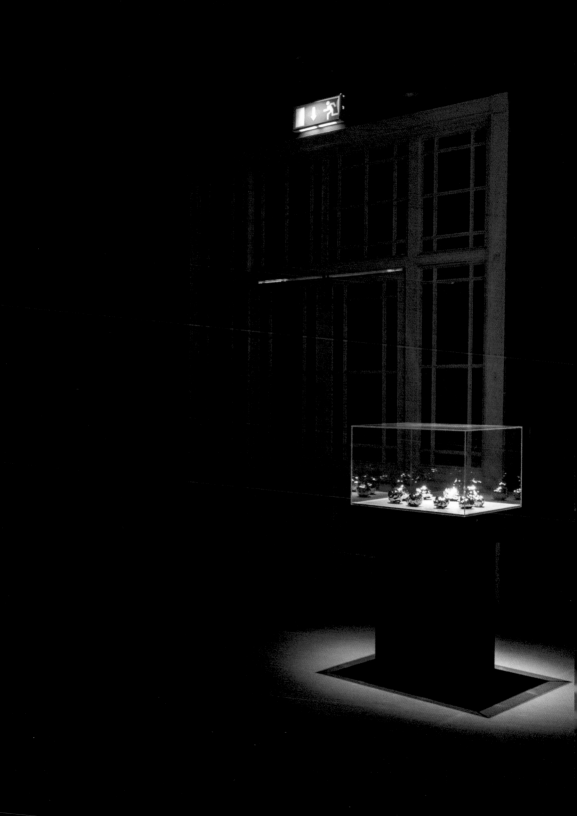

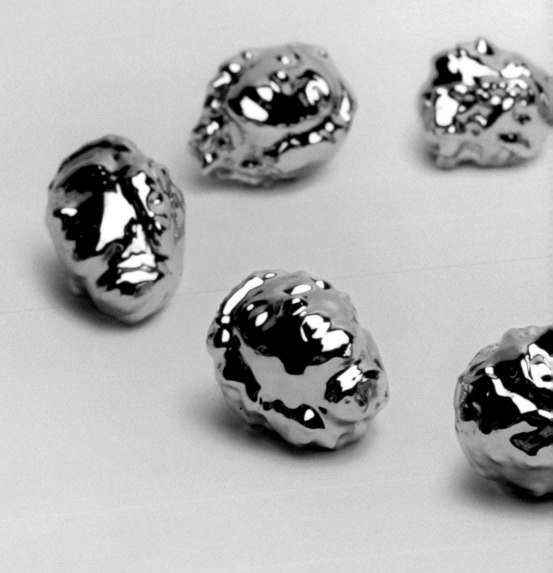

Gorget (2001), 9 pieces, 8 x 9 x 10cm, sizes variable
Chrome-plated cast bronze
Private collection

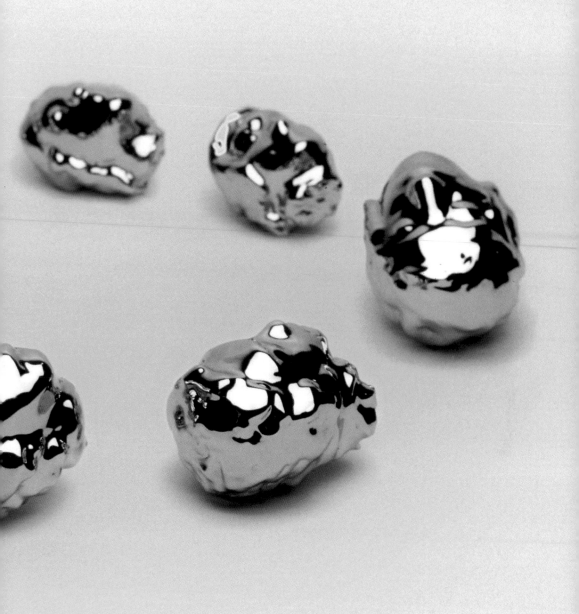

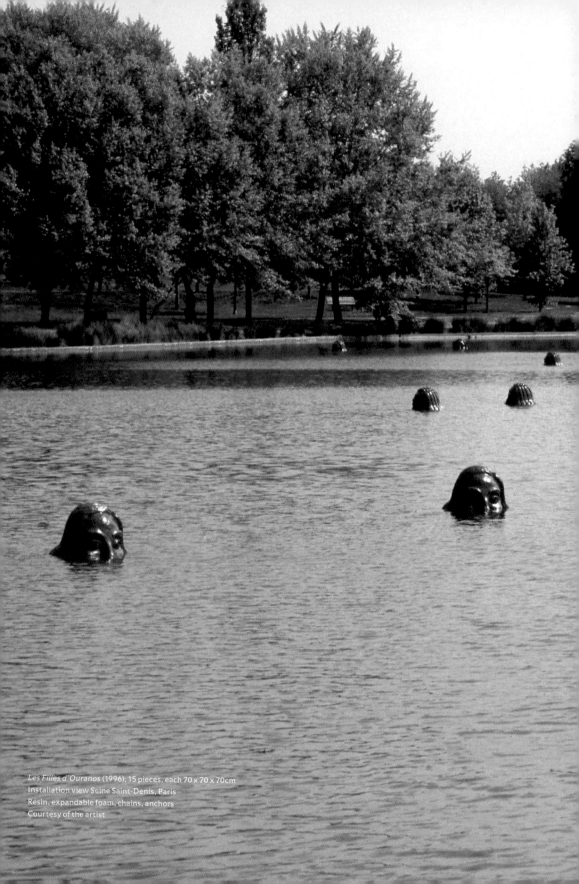

Les Filles d'Ouranos (1996), 15 pieces, each 70 x 70 x 70cm
Installation view Seine Saint-Denis, Paris
Resin, expandable foam, chains, anchors
Courtesy of the artist

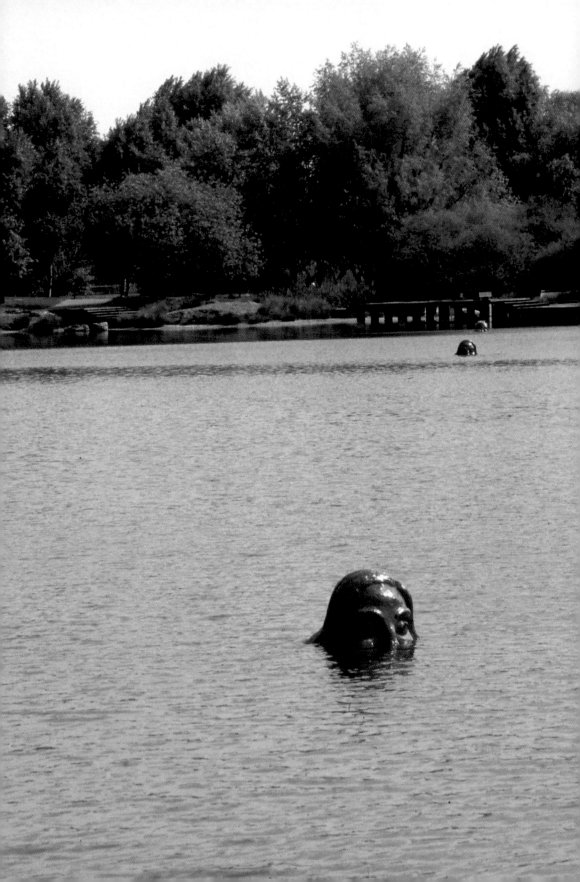

Bee Dress (1994), 13 x 26 x 27cm
Honeybees, cotton, wire
Collection: Arts Council of Northern Ireland

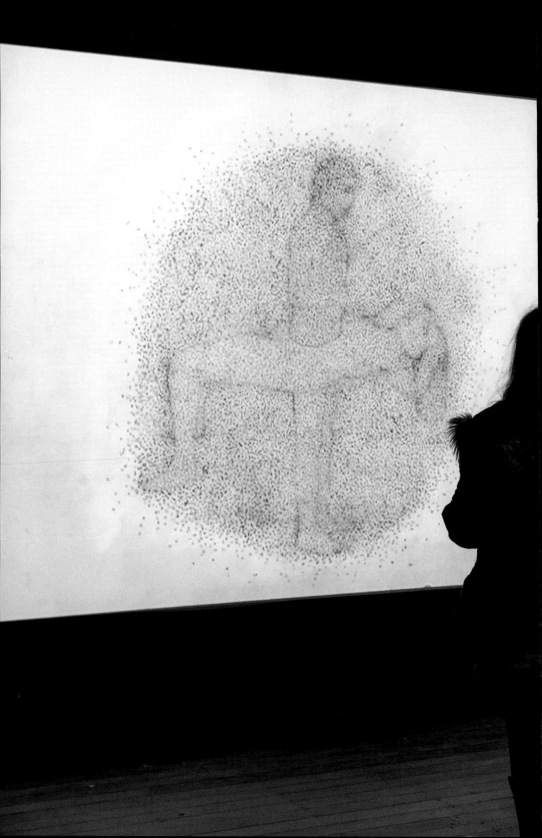

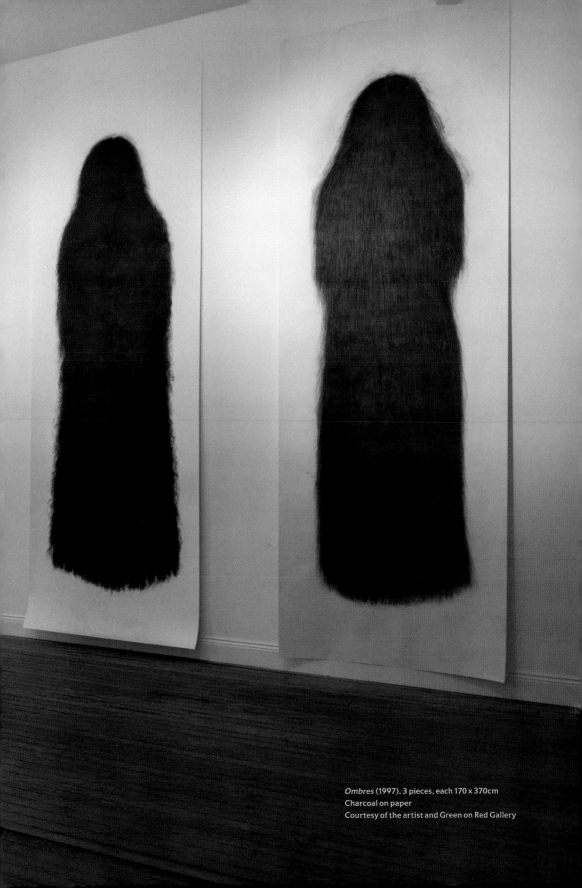

Ombres (1997), 3 pieces, each 170 x 370cm
Charcoal on paper
Courtesy of the artist and Green on Red Gallery

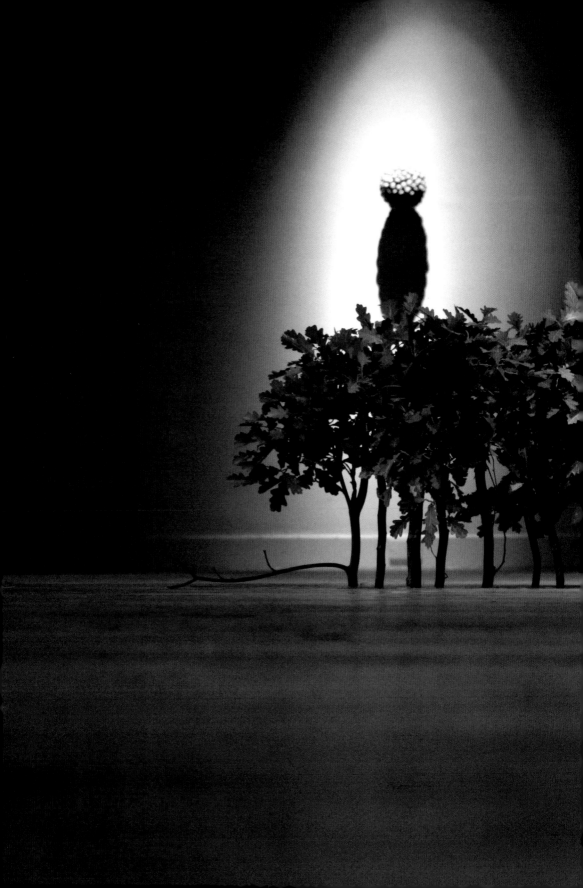

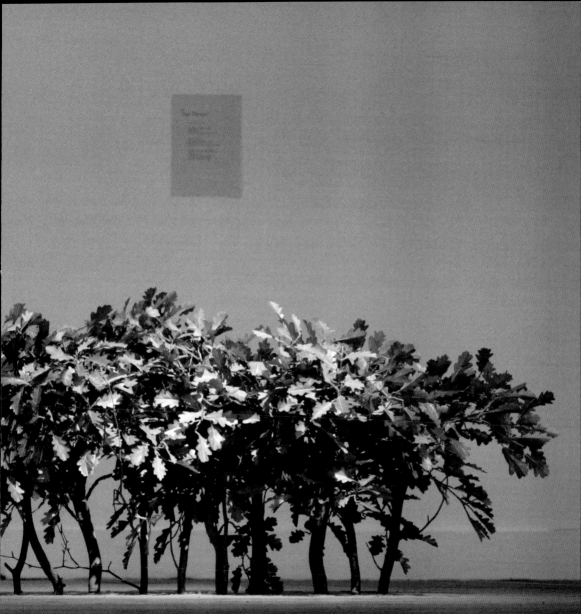

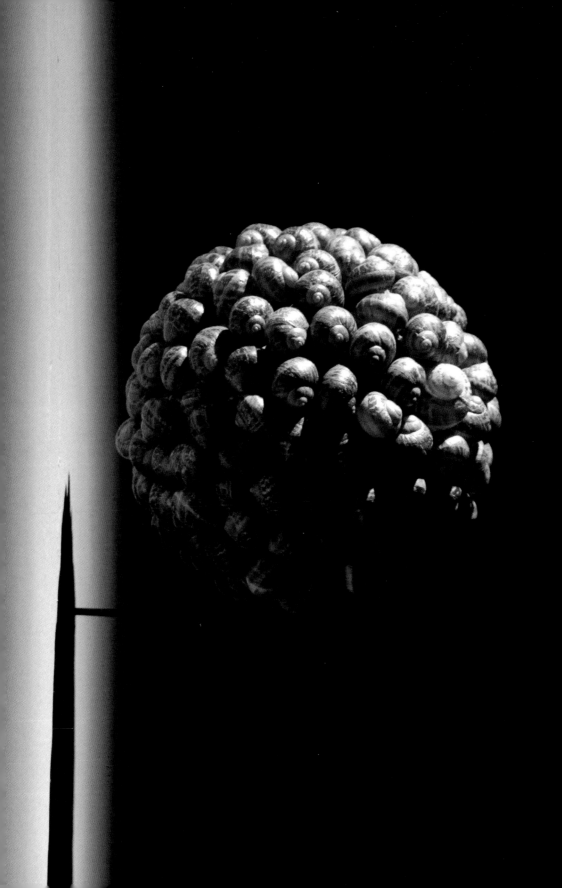

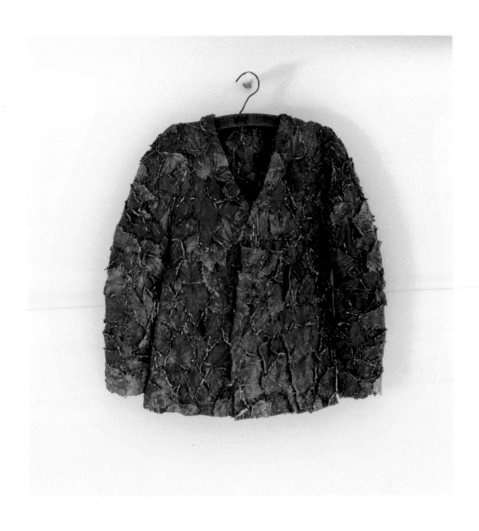

The Four Directions (2004), 27 x 27 x 27cm
Snail shells, polystyrene, glue
Private collection

Nettle Coat (1996), 5 x 60 x 70cm
Nettles, pins, hanger
Collection: Arts Council of Ireland

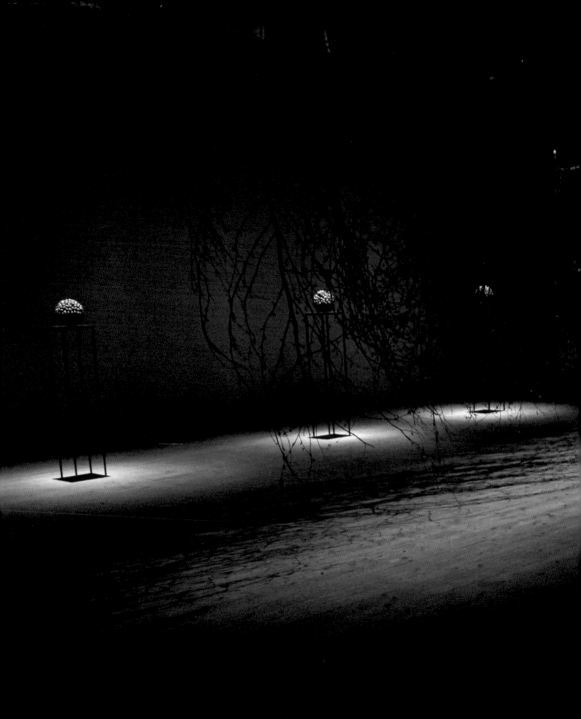

Rood (2005)
Installation view
Cast bronze, cast cement, beech
branches, glue, steel, snail shells
Installation view Green on Red Gallery

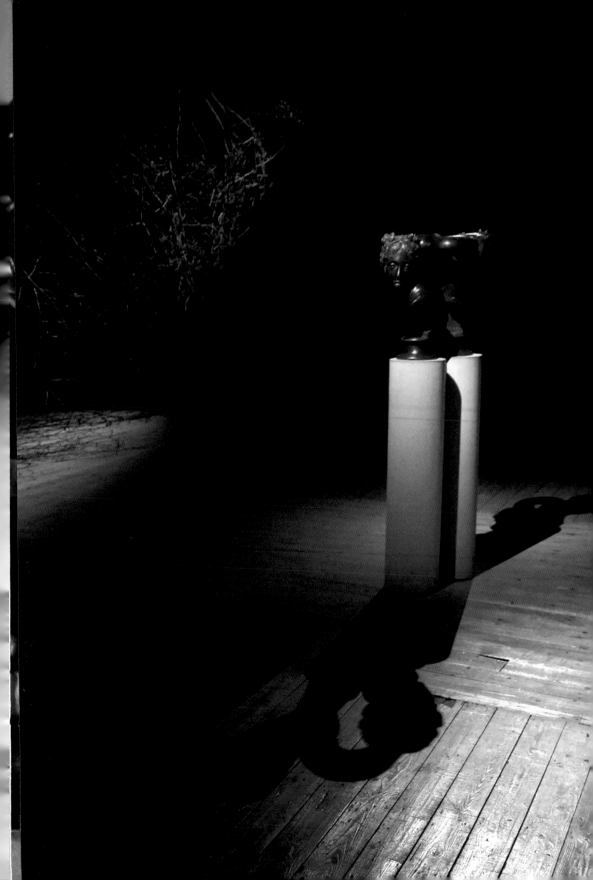

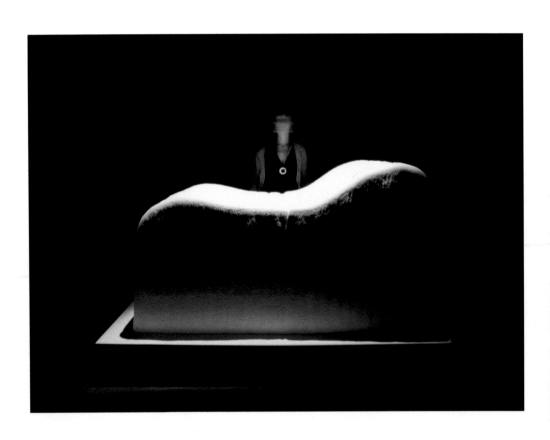

Mnemosyne (2002), 88 x 104 x 183cm
Stainless steel, copper piping, condensing
unit, corian, refrigeration gas
Courtesy of the artist

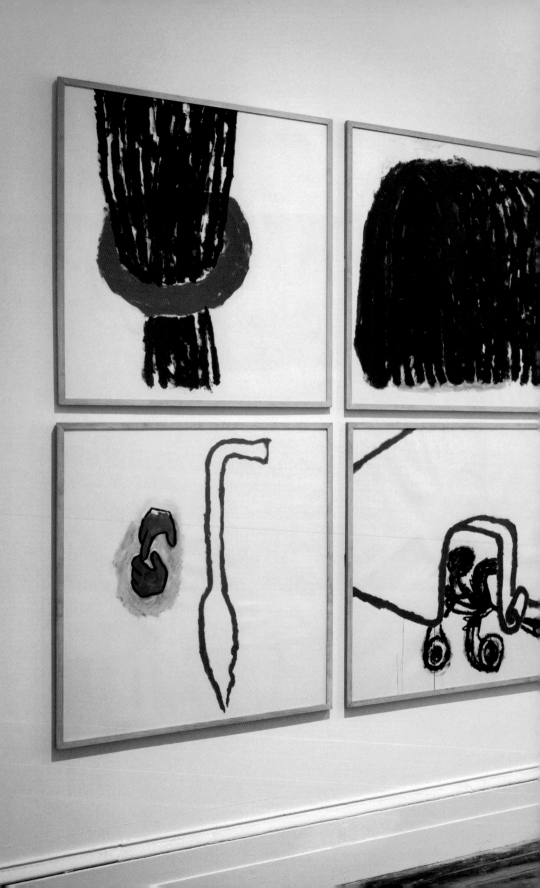

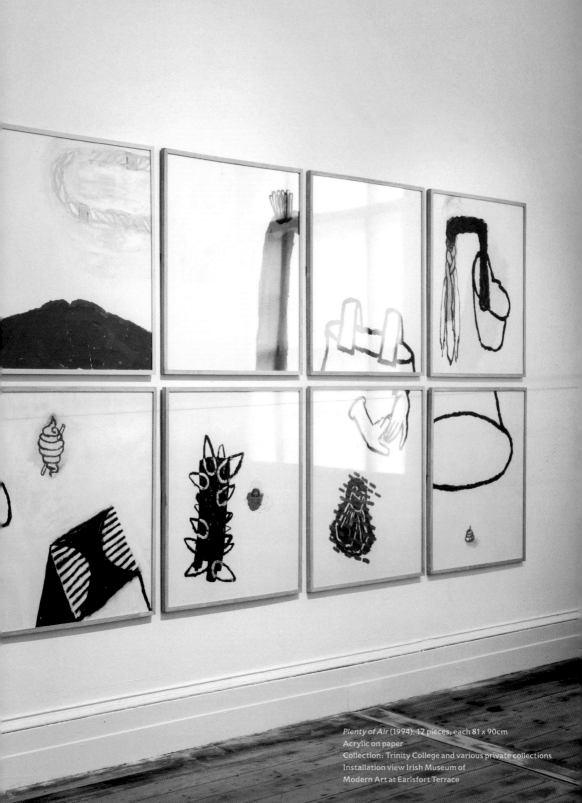

Plenty of Air (1994), 12 pieces, each 81 x 90cm
Acrylic on paper
Collection: Trinity College and various private collections
Installation view Irish Museum of
Modern Art at Earlsfort Terrace

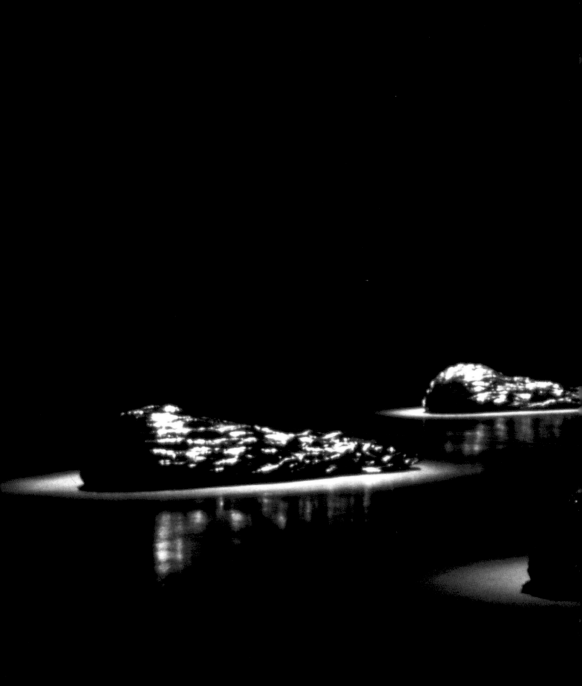

Swimmers (1996), detail, 9 pieces, each 12 x 35 x 60cm
Bronze
Installation view Centre d'art d'Ivry, Paris

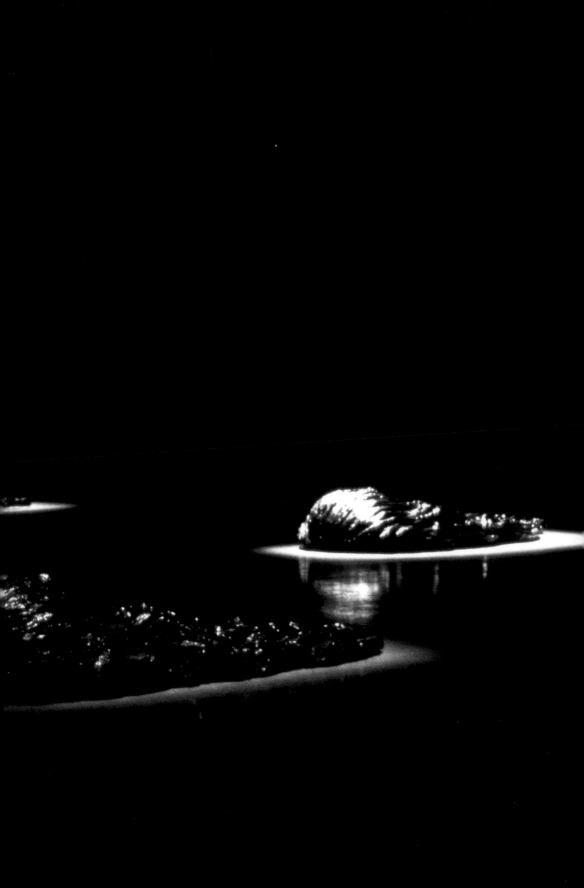

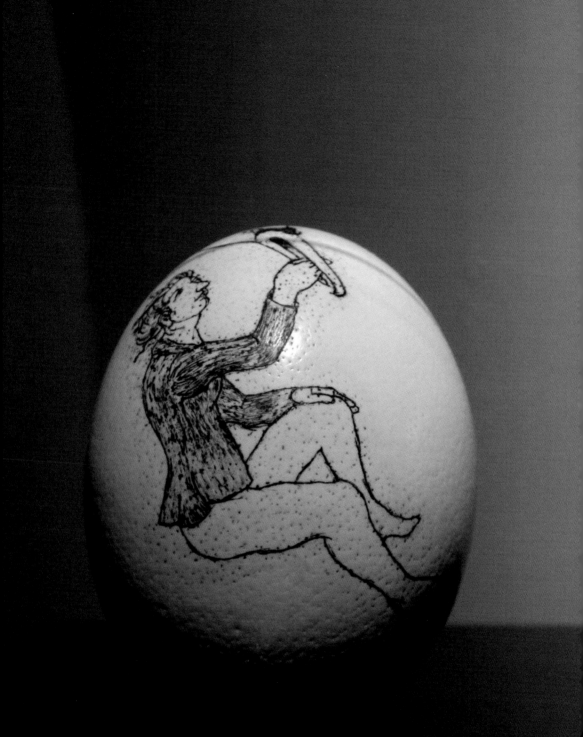

Les Jumeaux (2008), 10 x 11 x 18cm, sizes variable
Etched ostrich eggs
Private collection

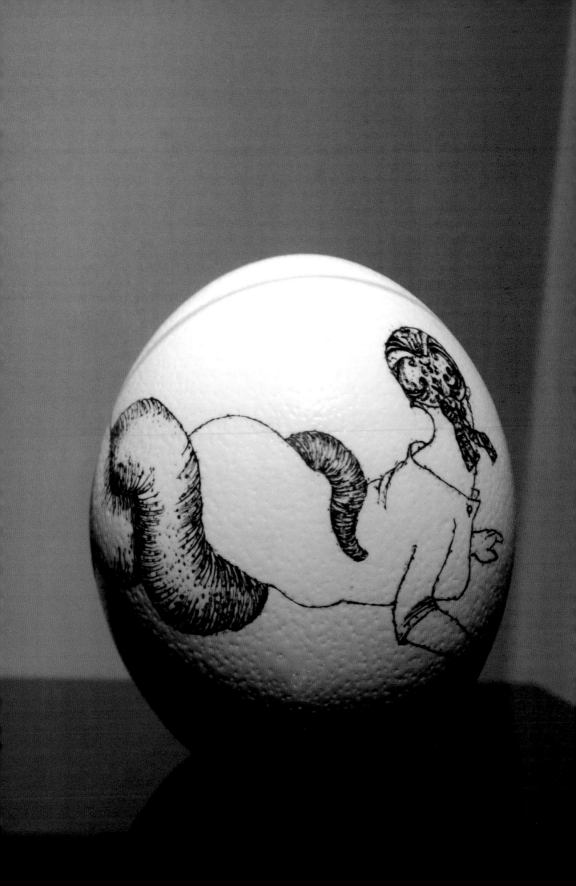

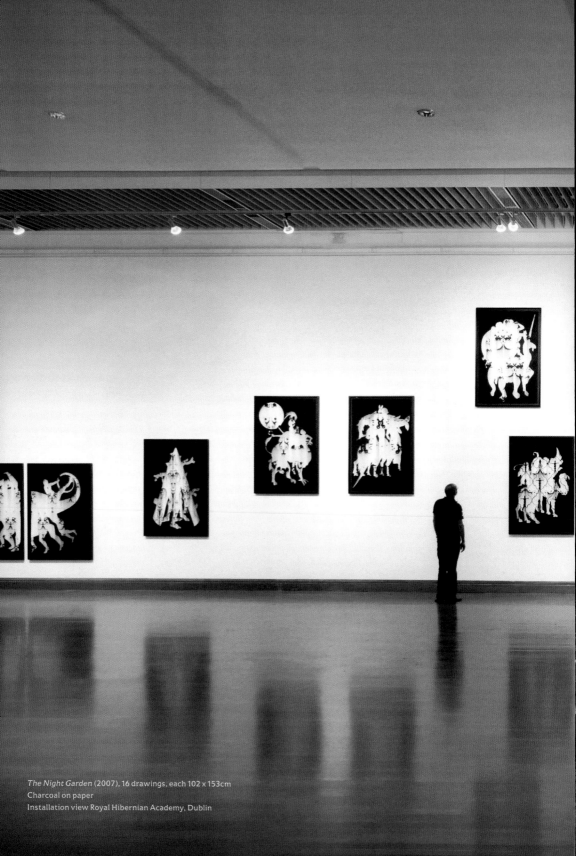

The Night Garden (2007), 16 drawings, each 102 x 153cm
Charcoal on paper
Installation view Royal Hibernian Academy, Dublin

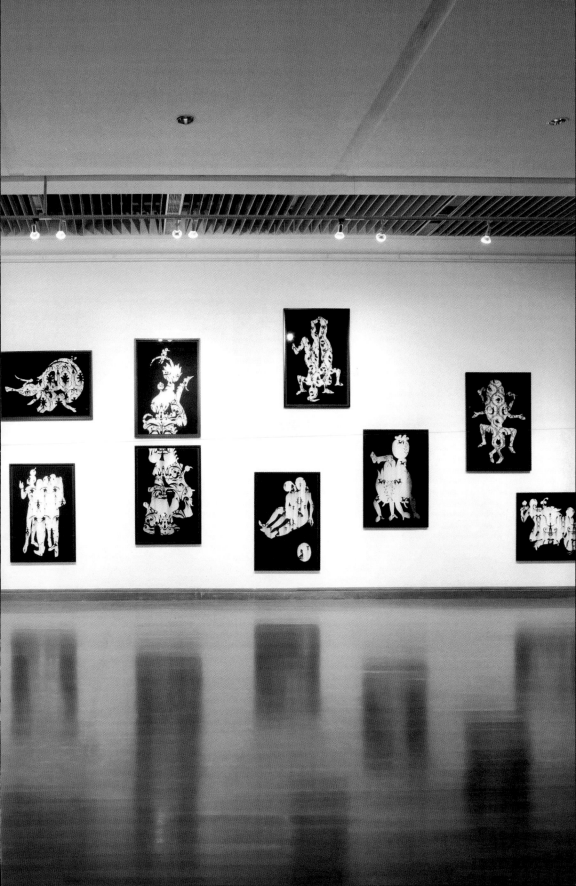

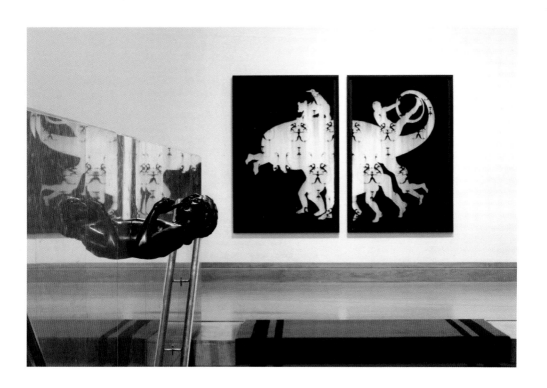

Beautiful Mouth (2006), 30 x 39 x 51cm
Bronze
Collection Limerick City Gallery of Art

Myriapod (2007), diptych, each 102 x 153cm
Charcoal on paper
Courtesy of David Nolan Gallery

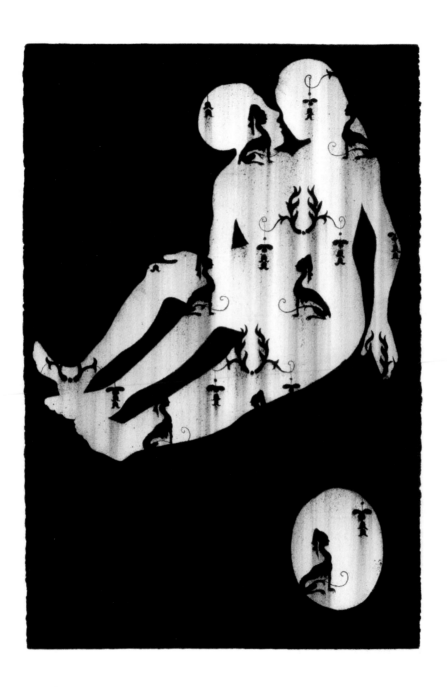

The Seduction (2007), 102 x 153cm
Charcoal on paper
Private collection

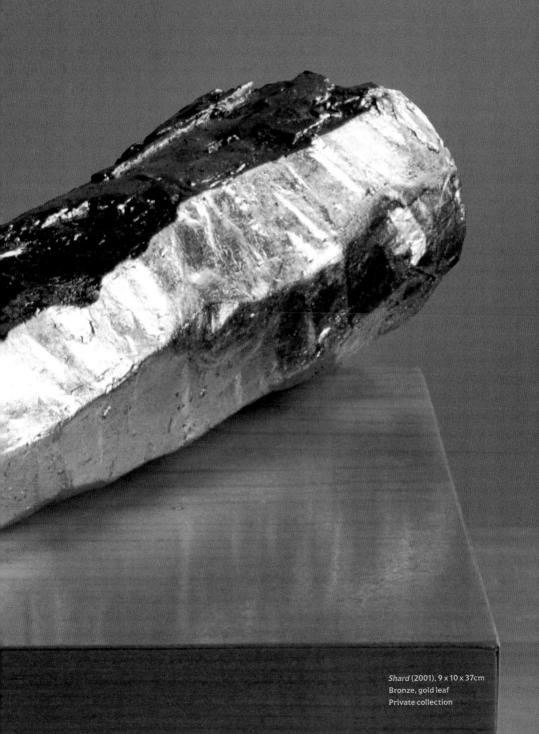

Shard (2001), 9 × 10 × 37cm
Bronze, gold leaf
Private collection

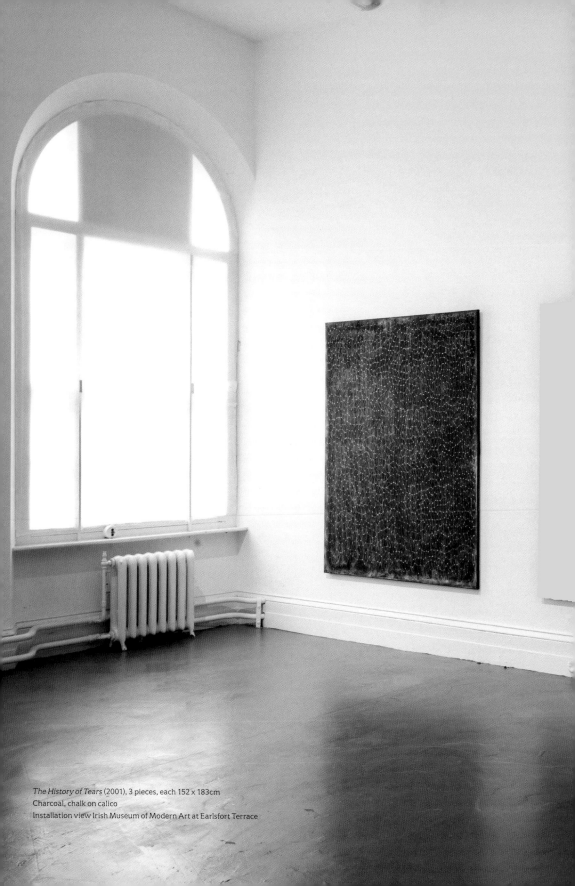

The History of Tears (2001), 3 pieces, each 152 x 183cm
Charcoal, chalk on calico
Installation view Irish Museum of Modern Art at Earlsfort Terrace

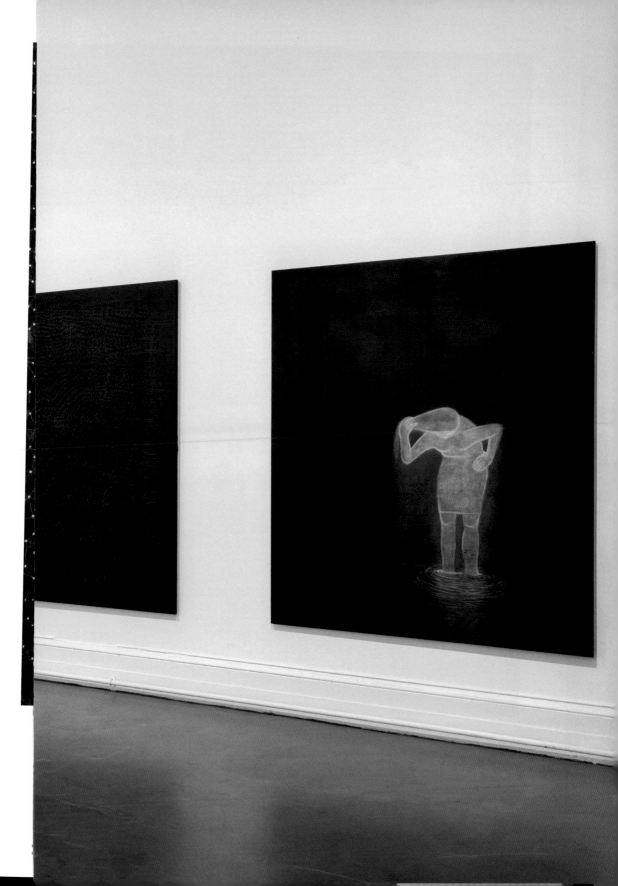

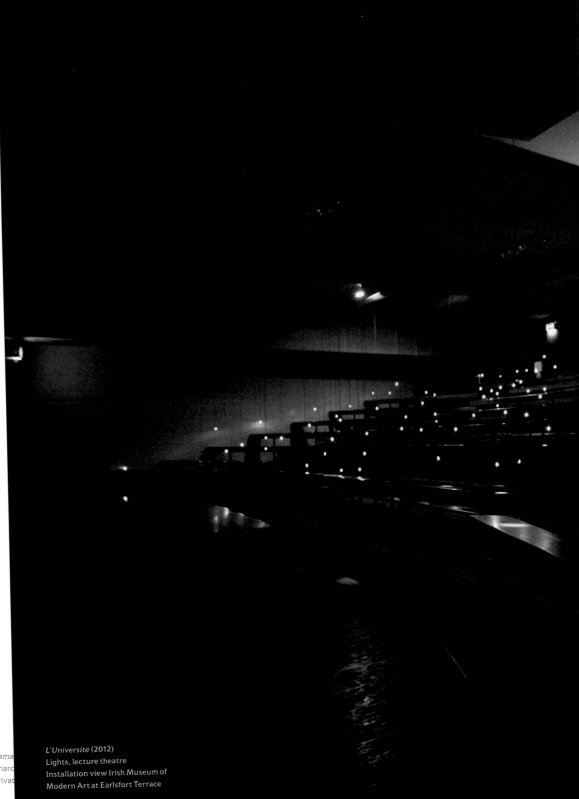

Cama
Charc
Privat

L'Université (2012)
Lights, lecture theatre
Installation view Irish Museum of
Modern Art at Earlsfort Terrace

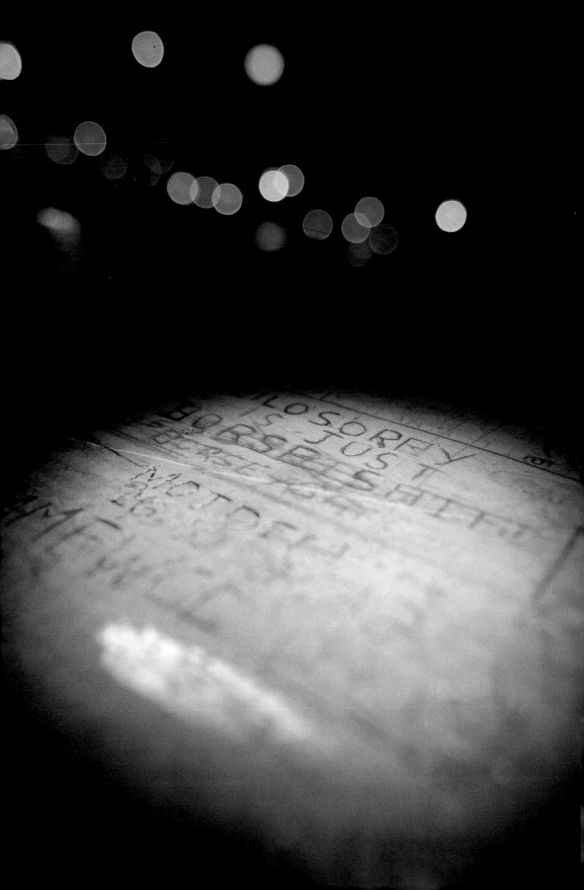

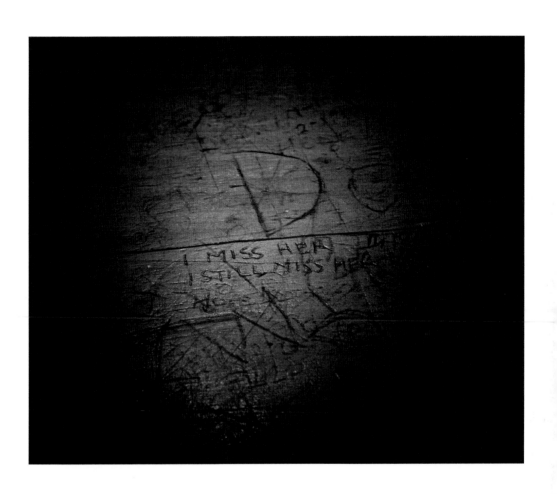

L'Université (2012), details

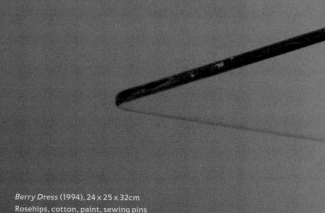

Berry Dress (1994), 24 x 25 x 32cm
Rosehips, cotton, paint, sewing pins
Collection: Irish Museum of Modern Art

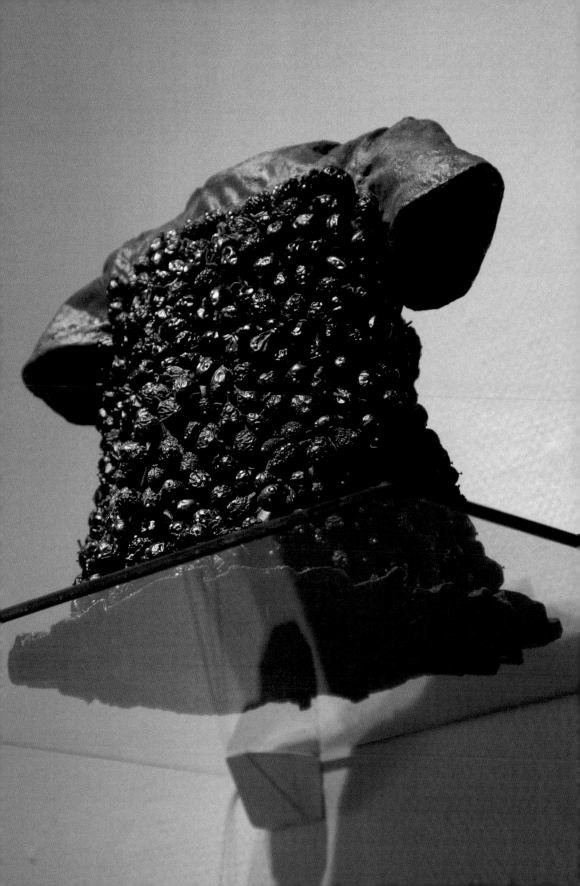

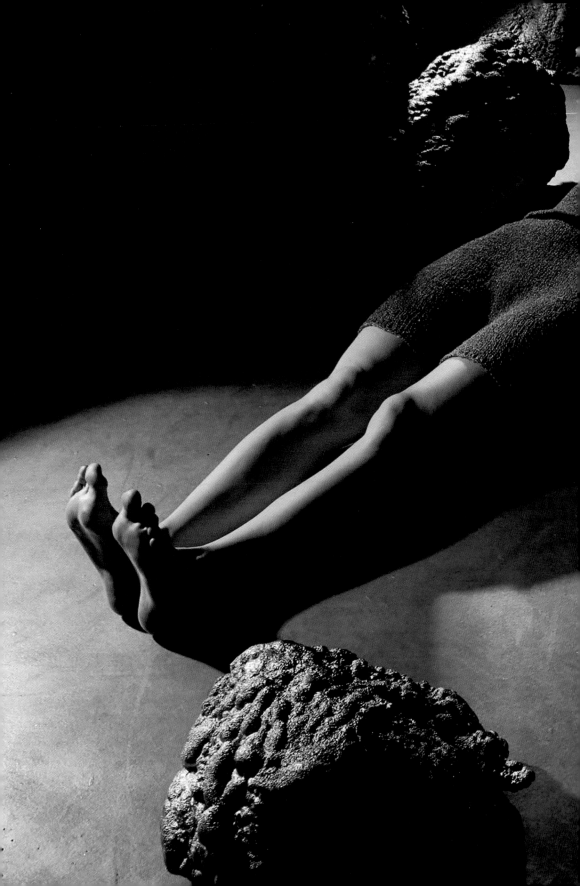

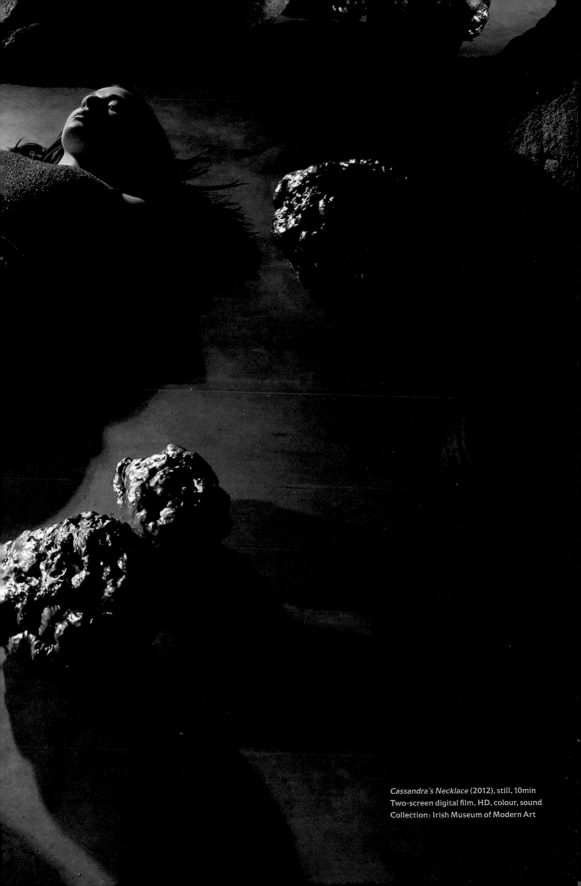

Cassandra's Necklace (2012), still, 10min
Two-screen digital film, HD, colour, sound
Collection: Irish Museum of Modern Art

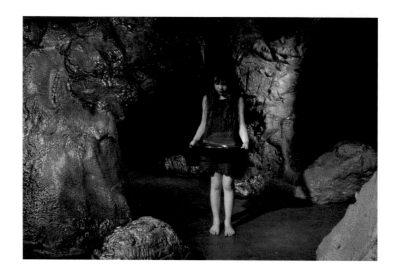

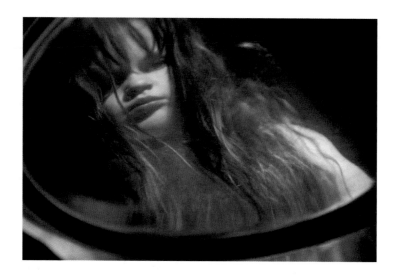

Cassandra's Necklace, film stills (2012)

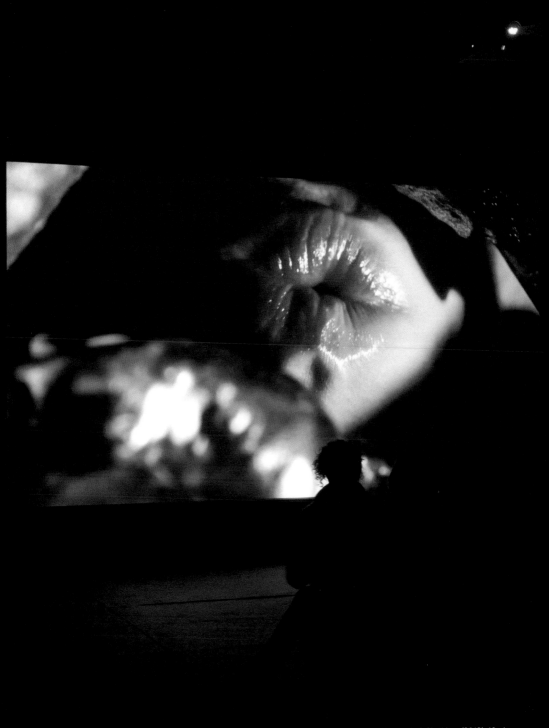

Cassandra's Necklace (2012), 10min
Two-screen digital film, HD, colour, sound
Installation view Irish Museum of Modern
Art at Earlsfort Terrace

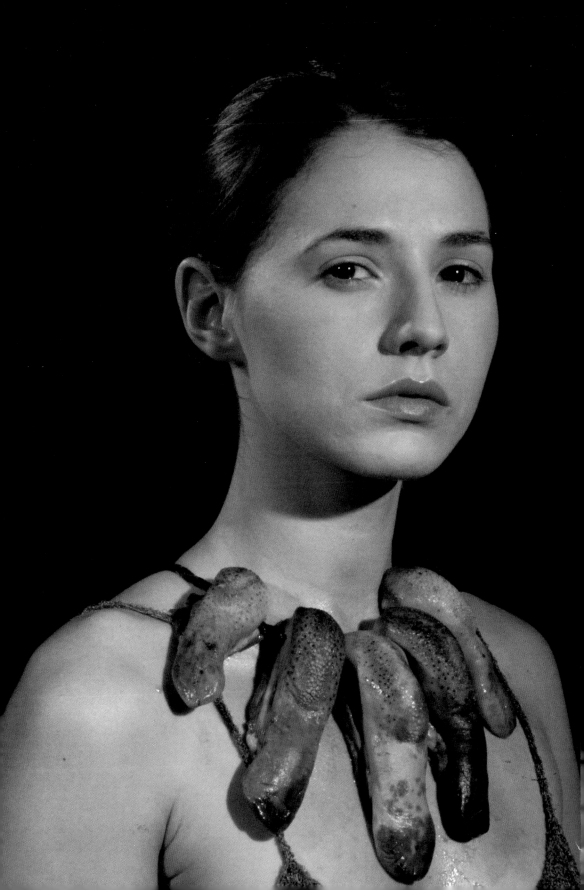

Cassandra's Necklace (2012), still, 10min
Two-screen digital film, HD, colour, sound
Collection: Irish Museum of Modern Art

DESIGNERS' NOTE
Conor & David

In early 2014 we met Alice Maher outside Partry in County Mayo. We spent the day in her studio looking through work, sketchbooks and collected ephemera, marking out potential content with brightly coloured Post-it notes.

Late in the afternoon, we all went for a walk with her dog on the bog nearby. As we walked, the topic of discussion was the book that would be the outcome of this collaboration. Our hope was that it might illustrate her own working method in a way that previous publications had not. It was on this walk that she described her working method: ideas, notes and observations gathering, mixing, and flowing into her work.

This process – the pool of images, thoughts and dreams streaming into completed work – has inspired the structural and aesthetic design of this book. It was important to us to show sketches and words as we had encountered them, in the full context of the spreads they inhabited, and to leave a trace of our shared marking system.

ACKNOWLEDGEMENTS

Stephanie Boner; Whitney Chadwick; Robert Russell, Graphic Studio Dublin; David Nolan Gallery, New York; Purdy Hicks Gallery, London; Green on Red Gallery, Dublin; Irish Museum of Modern Art; Ellen Kenny, Motherland; Austin McQuinn.

Photography Credits: Denis Mortell, Clíona O'Flaherty, Kate Horgan, Colm Hogan, Vivienne Dick, Miranda Driscoll, John Kellett, Donal Murphy, Jonathan Sammon, John Searle, Jean-Luc Terradillos, Jean Gailhoustet.

Film Credits: Trevor Knight, sound; Vivienne Dick, camera; Connie Farrell, editing; Charlie Murphy and Roisin Bradley O'Domhnaill, performers.

New York
Sep 99

160 PAGES

Reporters Notebook

RN8EAS

Got children

LB Vail

Give it Shop

PRIVATE

VENICE '11

Snake

Cassandra

WHITNEY

Tucson

Sisley

09 - '10

Alice

All related

Alice

Empreinte
Alice
POITIERS
Poitiers
1997

MEX

BARCELONA

Taro

2013
AUTUMN

Venice

CRYING

Root

ALICE MA

CATALUN